Creative Direct Mail Design

Design

The Guide and Showcase

Sheree Clark
Wendy Lyons

Rockport Publishers, Inc. • Rockport, Massachusetts

BUSINESS REPLY

FIRST-CLASS MAIL PERMIT NO. 00000 ANYTOWN STAT

POSTAGE WILL BE PAID BY ADDRESSEE

AST 1"

NO
MORE
THAN
2-1/4"

First published in the United States of America by:
Rockport Publishers, Inc.
146 Granite Street
Rockport, Massachusetts 01966
Telephone: (508) 546-9590
Fax: (508) 546-7141

Distributed to the book and art trade in the
U.S. and Canada by:
North Light, an imprint of
F & W Publications
1507 Dana Avenue
Cincinnati, Ohio 45207
Telephone: (513) 531-2222

ISBN 1-56496-143-5

10 9 8 7 6 5 4 3

Art Director: Laura Herrmann
Design Firm: Sayles Graphic Design
Layout /Production: Sara Day Graphic Design

Printed in Hong Kong

5/8"

NO POSTAGE
NECESSARY
IF MAILED
IN THE
UNITED STATES

This book is dedicated to John, Gary, and the United States Postal Service —without whom this book would not have been possible.

We extend heartfelt thanks to the graphic designers who graciously gave of their time and talent to make this book possible. We appreciate the effort you took to juggle phone interviews, send slides and samples, and provide encouragement and support. We are especially grateful to our dedicated editorial assistant, Darcie Saylor, for her unflagging enthusiasm and hard work.

A special thank you to: John Sayles and his remarkable talent in designing the book cover and layout.

Sandy Seley for inputting the manuscript onto disk.

Bill Nellans—whose outstanding photography makes the feature projects come alive.

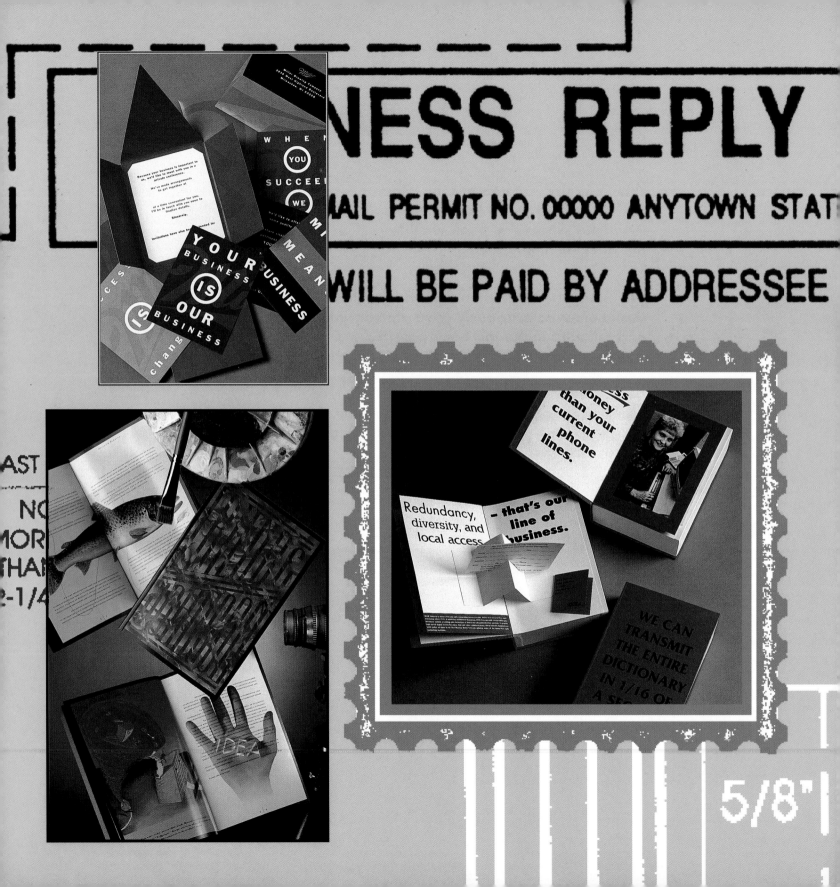

Table
of Contents

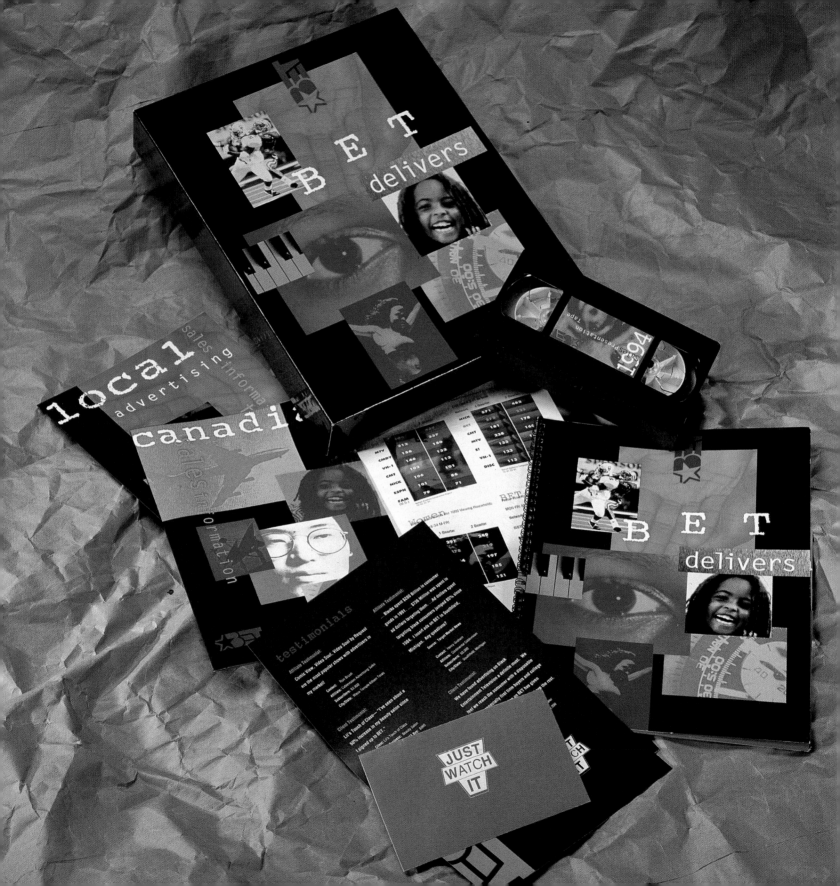

Introduction

Every day, millions of Americans get it. A majority look forward to getting it. There is probably some waiting for you at home right now. Think about it . . . what is one of the first things you do when you get home from your daily activities? Get the mail! Besides the usual bills and letters, studies show you'll probably find two pieces of direct mail advertising in your mailbox every day. Some of it gets opened...so the sender succeeds in getting their message out. Some gets thrown in the trash unopened. If you stop and think about why you open some direct mail and not others, you're taking the first step to designing successful direct mail.

Designing direct mail is a unique, creative challenge: Nine of the country's top direct mail designers are spotlighted here. They'll tell you their secrets for staying on the cutting edge of the industry by creating direct mail that gets results. You'll also find great tips from the copywriters and client service people whose talents contribute to the success of a direct mail campaign.

The nine features that follow highlight successful direct mail campaigns, including business-to-consumer direct mail, business-to-business direct mail, direct mail invitations/announcements, direct mail special event promotions, direct mail postcards and catalogs, non-profit/association mailings, development/fund-raising mailings, and three-dimensional direct mail. The gallery section showcases hundreds of the most clever direct mail pieces and campaigns ever created.

Direct mail advertising has been around for over a century. Since the 1980s, the direct mail industry has grown phenomenally... following a trend in lifestyle changes. For today's dual-income families, convenience has become critical. Consumers have fewer hours to shop, read, and relax, so they tend to spend less of their free time with traditional forms of advertising, such as the newspaper. But everyone looks forward to getting the mail, and they can read it at their convenience.

That is why direct mail has a distinct edge. In today's world, every man, woman, and child is exposed to thousands of advertising messages per day. If an advertiser can cut through the clutter, get the customer's attention, and be available when it's convenient, the customer will be more likely to receive the advertiser's message.

The nature of direct mail makes gauging the response automatic. It's simple to track how many pieces were mailed and how many business reply cards, orders, donations, or RSVPs come back. Direct mail's success in getting response is evident from the amount of money spent each year by businesses trying to attract consumer dollars. Direct mail is a 27 billion-dollar a year business, producing almost half of the U.S. Postal Service's volume. That's a mountain of 73 billion pieces per year!

Consumers are not only reading their direct mail, they're buying. In 1991, direct mail sales generated 212 billion dollars for American companies. That same year, charities raised close to 50 billion dollars through mail solicitation.

Creative design is another reason the direct mail industry is so successful. Consumers are interested when they find more in the mailbox than just a business envelope with a window. Direct mail pieces featuring samples, three-dimensional mailers, unusually shaped packages, and colorful envelopes start to sell the product before the box is even open.

A Plexiglas product display, a recipe box, a turkey feather, a can of sardines, and a corrugated pop-out football are just some of the unique direct mail design ideas you'll find in this book. So, keep an open mind...and you'll discover new and exciting ways to get results with creative direct mail design.

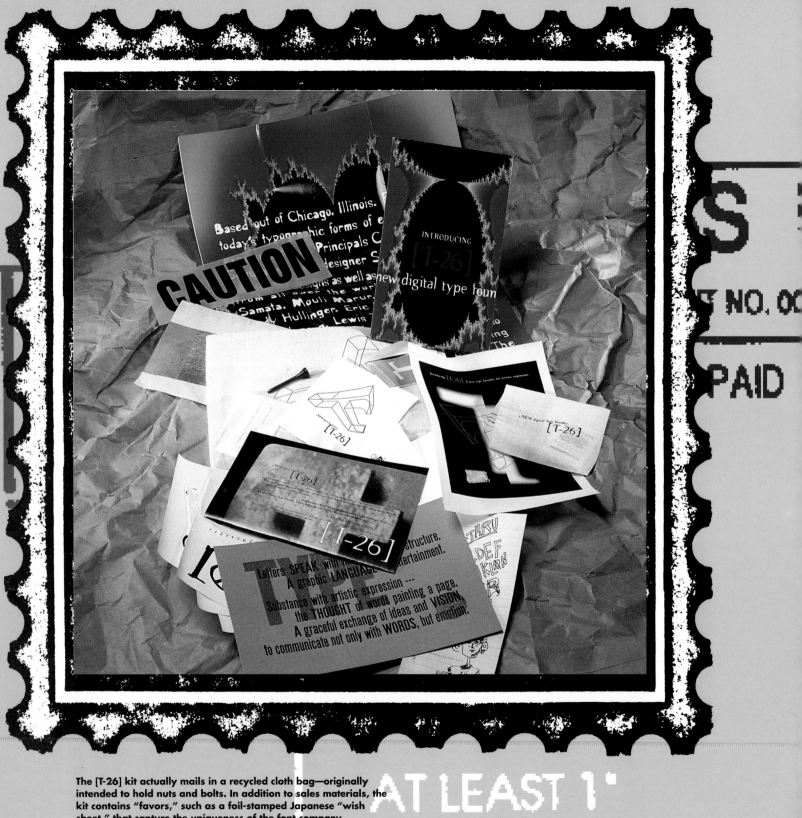

The [T-26] kit actually mails in a recycled cloth bag—originally intended to hold nuts and bolts. In addition to sales materials, the kit contains "favors," such as a foil-stamped Japanese "wish sheet," that capture the uniqueness of the font company.

Business -to-Consumer
Direct Mail

Every business that uses direct mail dreams of a mailing that takes on a life of its own—a piece that gets response by presenting the company's product, mission, and beliefs so well that the recipient takes action—and orders come pouring in.

When designer Carlos Segura and his partner, Scott Smith, established the type foundry [T-26], they wanted it to be more than just a source of type styles on disc for computer users. They wanted to create a new kind of font company, one that could offer low-priced fonts and student discounts, but could also reward its designers with good commissions. Their focus was to give artistic minds from all over the world a forum for self-expression. The resulting font collection is unique, cutting-edge, and personal.

The resulting direct mail piece—like everything else at [T-26]—breaks the rules. Propelled by the tremendous success of the direct mailing, the company is growing faster than Segura and Smith ever thought possible.

[T-26] fonts are sold only by mail-order. The company places ads in consumer publications, such as the music and style-oriented magazine *Raygun*. Less than five years ago only professional designers bought fonts; now, anyone with a computer is a potential customer. Customers call or write for a [T-26] direct mail kit, which includes a font catalog for orders.

The kit doesn't look like a direct mail piece. Founding designer Segura enjoys collecting CDs, especially CDs with knick-knacks in

TIPS FOR EFFECTIVE DIRECT MAIL DESIGN

1. Break the rules.

2. DON'T listen to people who say you can't break the rules.

3. See #1.

them, and the kit follows this design lead. Each one comes in a screen-printed cloth bag and includes the [T-26] catalog, a poster, flyer, and assorted [T-26] "favors."

Everything has a message: a napkin indicates that the font collection will make you drool, a yellow crime-scene tape cautions that these fonts will evoke strong emotions, so be careful how they're used. There's even a little drawing done by Smith while he was on the phone. Segura and Smith think the drawing personifies the company's fun, enthusiastic spirit—so they put it in.

The kit's poster and accompanying flyer talk about the company and invite font submissions. The tone of the copy is purposely conversational—to communicate a casual-yet-energetic approach. The font catalog—like the rest of the package—is unique. First, it is unbound; this is a logistic requirement since pages of new fonts are added daily. Second, it's written in verse. Wanting to avoid the traditional, dry catalog copy, Segura and Smith

hired poet Dan X. O'Neil to write the text for [T-26].

A "thank-you bag" completes the package. In it, a golf tee imprinted "26" (tee-26), a towelette for computer screens, and a business card thank customers for their orders. Segura thinks it's important to say thank-you; responses to this part of the kit prove him right. Customers are touched. "Emotions get involved when you give people something that says you're emotionally involved," he explains. "It's back to the good old days of customer service. We care."

In addition to generating great response, Segura and Smith's design has become a hot property. Recipients try to collect the 10 different kits produced so far. They also fax Segura and Smith to say how much they like the mailing, and send gifts and drawings of their own. A typical response, faxed from Argentina, summed up the direct mail magic of [T-26]. It read, "I love the kit's playful and frisky sense of beauty." ∎

CLIENT:
[T-26]
DESIGN FIRM:
Segura, Inc.
Chicago, Illinois
ART DIRECTOR:
Carlos Segura
DESIGNER:
Carlos Segura, Scott Smith
COPYWRITER:
Dan X. O'Neil

The font catalog is unbound so it can be updated daily on a computer.

Not less Than 1/2" Between ZIP Code

The "thank-you bag" is included as a gift to the recipient for requesting the kit.

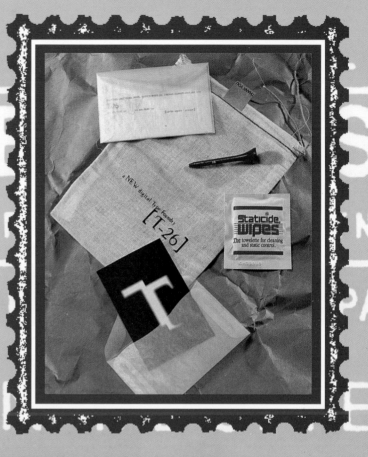

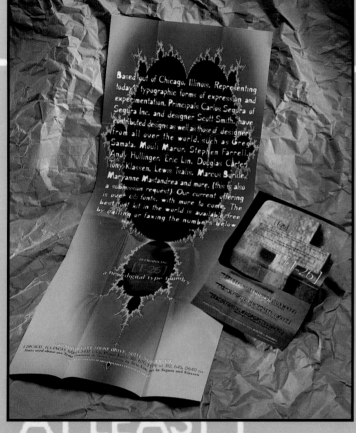

A poster and flyer explain the company's mission and solicit font contributors. Artwork from the poster was also used as a magazine ad to promote [T-26].

The [T-26] mailing is made from recycled materials and found objects. Contents of the kits change constantly—10 have been produced so far—and are quickly becoming collectible.

NO MORE

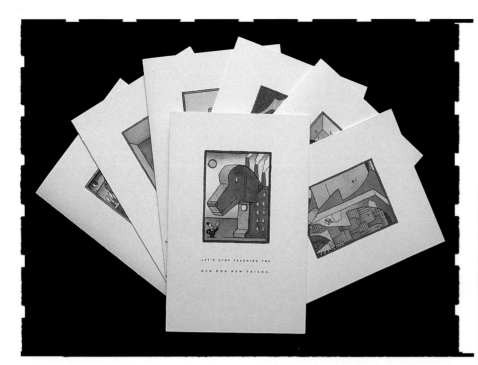

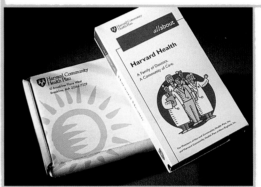

CLIENT:
The Wyatt Company
DESIGN FIRM:
Pressley Jacobs Design
Chicago, Illinois
ALL DESIGN:
Mark Myers
ILLUSTRATOR:
James Kaczman

This series of mailers uses attractively illustrated cliches as a focal point.

CLIENT:
Harvard Community Health Plan
DESIGN FIRM:
Clifford Selbert Design
Cambridge, Massachusetts
ART DIRECTOR:
Lynn Riddle
DESIGNER:
Mike Balint, Iesa Figueroa,
Darren Namaye, Lynn Sampson
ILLUSTRATOR:
Burton Morris

Part of designing a whole new look for New England's largest HMO included the creation of a sleeve and mailer for the orientation videotape.

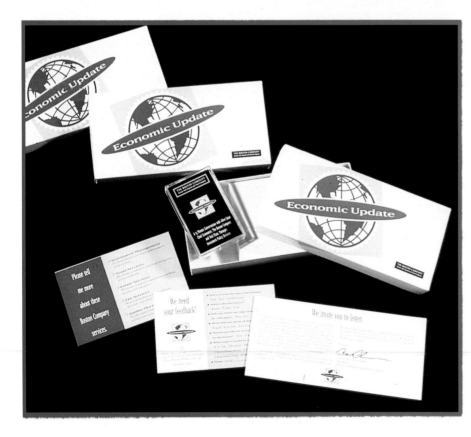

CLIENT:
The Boston Company
DESIGN FIRM:
Clifford Selbert Design
Cambridge, Massachusetts
ALL DESIGN BY:
Mary Lewis Chiodo
ILLUSTRATOR:
James Krause

The Boston Company's direct mail insert reads, "We invite you to listen." Cheerful graphics on the box lid tell the story; inside, an audiotape features experts speaking on global topics and providing recommendations for making the most of economic opportunities.

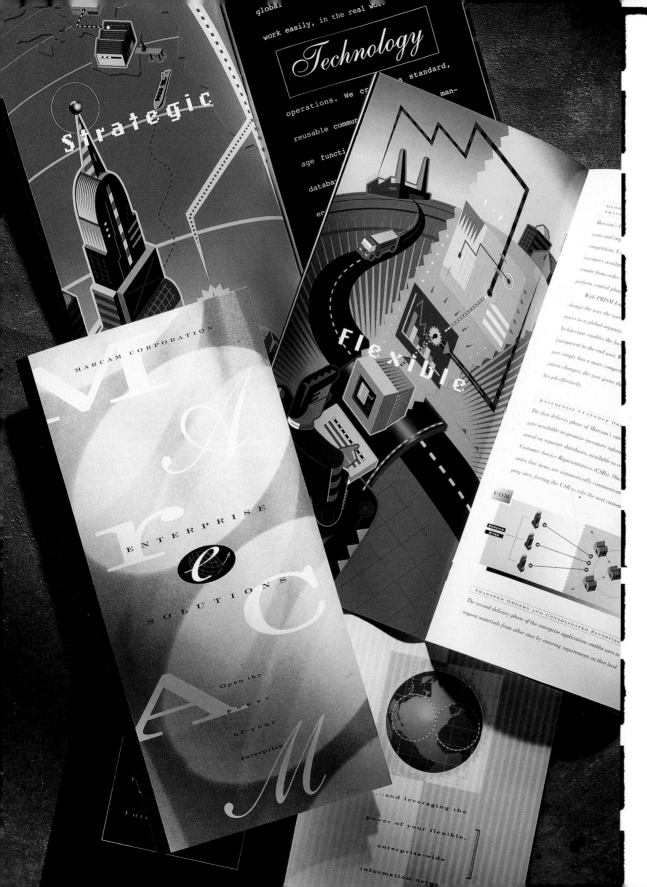

CLIENT:
Marcam Corporation
DESIGN FIRM:
Polese Clancy
Boston, Massachusetts
ART DIRECTOR:
Ellen Clancy
DESIGNER:
Thomas Riddle
ILLUSTRATOR:
Steve Lyons

A likely combination: Computer illustrations are incorporated into this international brochure for computer software.

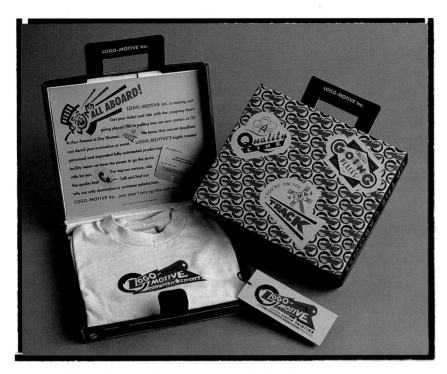

CLIENT:
Logo-Motive Inc.
DESIGN FIRM:
**Sayles Graphic Design
Des Moines, Iowa**
ALL DESIGN BY:
John Sayles

**This promotional mailing for a screen printer
includes a custom T-shirt. Mailed in a suitcase-
shaped box, the mailer features bold train-
inspired graphics.**

CLIENT:
Access Graphics/Sun Select
DESIGN FIRM:
**Malowany Chiocchi Design
Boulder, Colorado**
ALL DESIGN BY:
Gene Malowany
PHOTOGRAPHER:
Chris Baker

**This sales incentive program got positive results by using three
different stages. "So Many Roads . . . So Little Time" was the
theme of the initial keychain viewfinder mailing.**

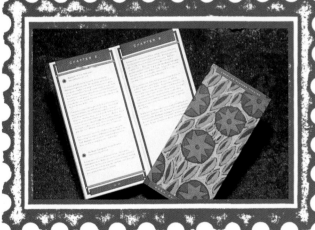

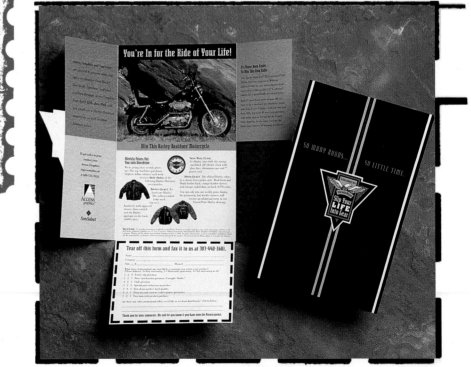

CLIENT:
American Players Theatre
DESIGN FIRM:
**Planet Design Company
Madison, Wisconsin**
ART DIRECTOR:
Dana Lytle, Kevin Wade
DESIGNER:
Dana Lytle
ILLUSTRATOR:
Dana Lytle

**The "Book of Summer" campaign, now in its fourth sea-
son, has continued to break ticket sales records each year
that it has been in place.**

CLIENT:
Dallas Society of Visual Communications
DESIGN FIRM:
Sibley/Peteet Design, Inc.
Dallas, Texas
ART DIRECTOR:
Rex Peteet
DESIGNER:
Rex Peteet, Derek Welch
ILLUSTRATOR:
Rex Peteet, Derek Welch, Mike Schroeder
PHOTOGRAPHER:
Phil Hollenbeck

Using "In/Out" as a theme, this mailing is part of a campaign for a communications competition. Winning entrants receive a preview invitation and a kraft liquor bag to bring to the BYOB event.

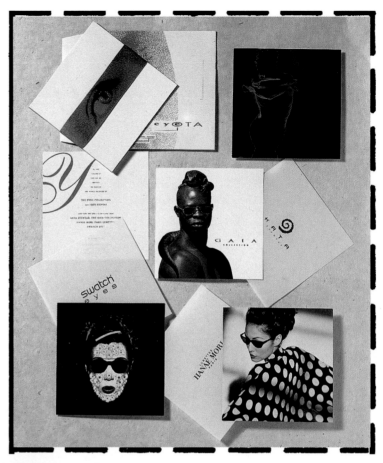

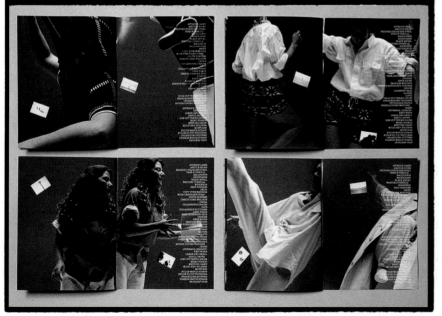

CLIENT:
eyeOTA
DESIGN FIRM:
eyeOTA Inhouse Studio
Culver City, California
ART DIRECTOR:
David Kilvert
DESIGNER:
Krista Kilvert, David Kilvert

Individual vellum sheets differentiate each product line in this eyewear collection. Joined by a paper strap, the mailing can be modified according to specific needs.

CLIENT:
1x1:z (Japan)
DESIGN FIRM:
Sam Smidt Studio
Palo Alto, California
ALL DESIGN BY:
Sam Smidt
PHOTOGRAPHER:
Raja Muna

This series of mailings promotes a line of ready-to-wear accessories. High-action photography and close-up shots add youthful appeal.

CLIENT:
American Players Theatre
DESIGN FIRM:
**Planet Design Company
Madison, Wisconsin**
ART DIRECTOR:
Dana Lytle, Kevin Wade
DESIGNER:
Dana Lytle
ILLUSTRATOR:
Dana Lytle
COPYWRITER:
John Anderson

**Together, vibrant colors,
tactile paper stock, classical
type treatment and clever
copywriting convey a sense
of this summer outdoor
theatre.**

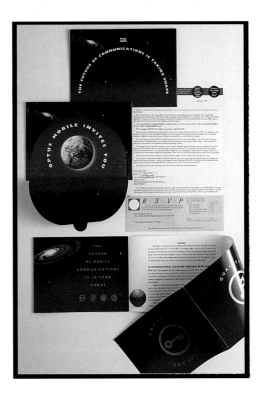

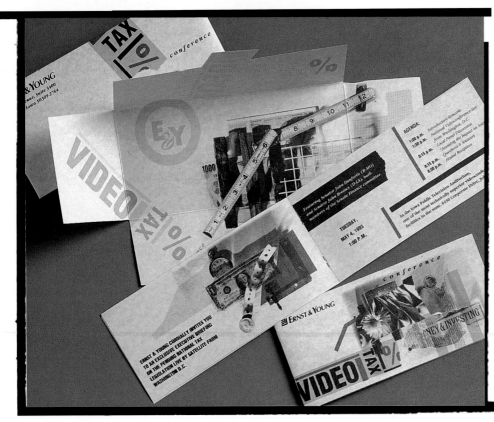

CLIENT:
Optus Communications
AGENCY:
**K&D Bond Direct
Sydney, Australia**
ART DIRECTOR:
Bruce Bennett
DESIGNER:
Peter Keeble

**By pulling a tab—marked "pull here" to get
attention—the recipient gets the rest of the mes-
sage.**

CLIENT:
Ernst & Young
DESIGN FIRM:
**Sayles Graphic Design
Des Moines, Iowa**
ALL DESIGN BY:
John Sayles
PHOTOGRAPHER:
Bill Nellans

**Using a photo-collage as a visual,
this mailer promotes a tax seminar.**

CLIENT:
Hong Kong Dragon Airlines
DESIGN FIRM:
PPA Design
Hong Kong
ART DIRECTOR:
Byron Jacobs
DESIGNER:
Byron Jacobs, Michele Shek
PHOTOGRAPHER:
Frank Chung

To promote a special honeymoon travel package, an airline, a travel agency, and a bridal salon joined forces to produce this mailing. The theme is taken from traditional Japanese wedding customs.

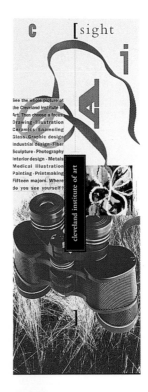
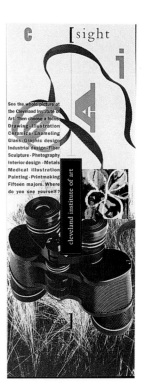

CLIENT:
Cleveland Institute of Art
DESIGN FIRM:
Nesnadny + Schwartz
Cleveland, Ohio
ART DIRECTOR:
Joyce Nesnadny, Mark Schwartz
DESIGNER:
Joyce Nesnadny, Michelle Moehler
PHOTOGRAPHER:
Robert Muller, Tony Festa

This mailer design helped its art institute client economize. Using the same art for subsequent years saves money, changing the mailer's color seasonally keeps the graphics looking fresh.

CLIENT:
YMCA Downtown Dallas, Texas
DESIGN FIRM:
Peterson & Company
Dallas, Texas
ALL DESIGN BY:
Pham Nhan
PHOTOGRAPHER:
Rick Moore

Sparse copy is presented in a bullet-point style in this brochure for the YMCA.

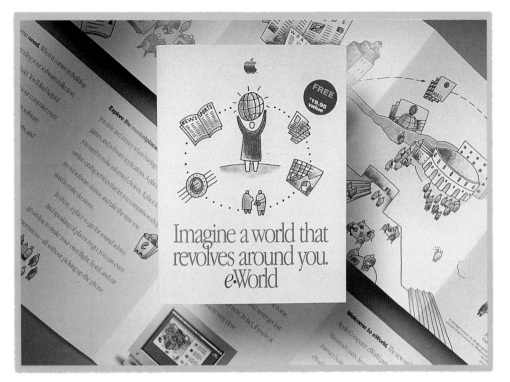

CLIENT:
Apple Computer, Inc.
DESIGN FIRM:
International Events/CKS
Palo Alto, California
ART DIRECTOR:
Mark Drury, Tim Kain
DESIGNER:
Mark Drury, Tim Kain
ILLUSTRATOR:
Mark Drury

Each unfolding page introduces the reader to another facet of eWorld with words and illustration.

CLIENT:
Loyola University Chicago
DESIGN FIRM:
Sayles Graphic Design
Des Moines, Iowa
ALL DESIGN BY:
John Sayles

Aptly entitled "Rush Hour," this mailer is sent to recruit students for fraternity and sorority "rush" activities.

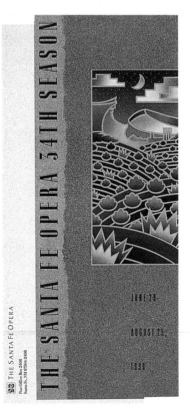

CLIENT:
Santa Fe Opera
DESIGN FIRM:
Vaughn Wedeen Creative
Albuquerque, New Mexico
ART DIRECTOR:
Rick Vaughn
DESIGNER:
Rick Vaughn
ILLUSTRATOR:
Gary Cascio, Kevin Tolman

To entice people to attend the opera, and to visit Santa Fe as well, this brochure makes it easy to buy tickets and get information. The printed piece's unusual size, texture, and use of color help it stand out in the mail.

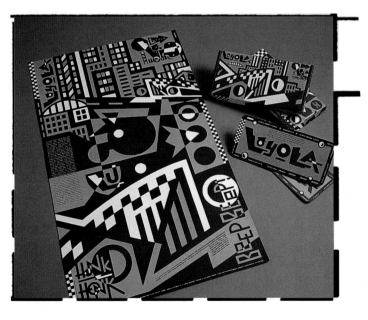

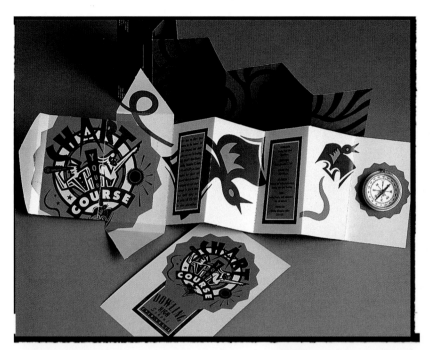

CLIENT:
Dowling High School
DESIGN FIRM:
Sayles Graphic Design
Des Moines, Iowa
ALL DESIGN BY:
John Sayles

Created as part of a campaign to recruit new students, the last panel of this mailer includes an actual, working compass.

CLIENT:
The Flying Marsupials
DESIGN FIRM:
Sayles Graphic Design
Des Moines, Iowa
ALL DESIGN BY:
John Sayles

A special-edition CD was mailed to consumers in a chipboard envelope. Inside, a kangaroo character becomes a display to hold the new release.

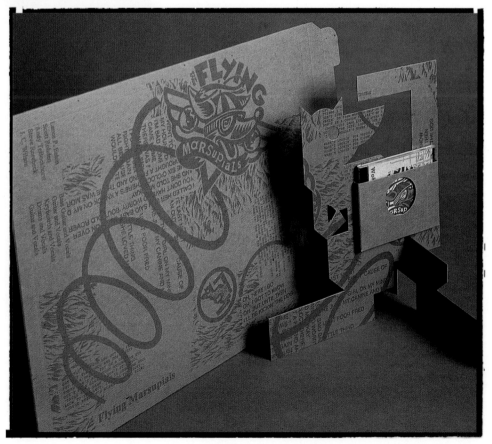

CLIENT:
Art Directors Club of Metropolitan Washington
DESIGN FIRM:
Supon Design Group, Inc.
Washington, D.C.
ART DIRECTOR:
Supon Phornirunlit
DESIGNER:
Richard Lee Heffner

A membership recruitment mailer, this piece gets its unique identity from photocopies of photos. The program includes matching letterhead and envelopes.

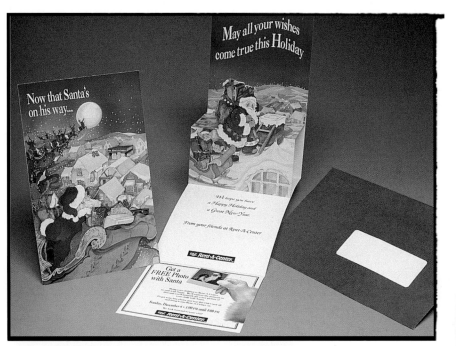

CLIENT:
Rent-A-Center
DESIGN FIRM:
Target Com, Inc.
Chicago, Illinois
ART DIRECTOR:
Ricardo Quayat
COPYWRITER:
Mark Bloom
ILLUSTRATOR:
Gwen Connely
PHOTOGRAPHER:
John Fraugoulis

This piece owes its success to mechanics: in order to display the stand-up card, the recipient must tear off the response coupon. Thus, it is more likely to be redeemed.

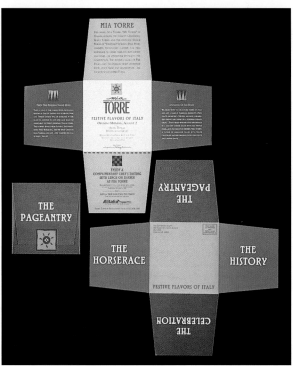

CLIENT:
Mind Extension University
DESIGN FIRM:
Vaughn Wedeen Creative
Albuquerque, New Mexico
ART DIRECTOR:
Steve Wedeen
DESIGNER:
Steve Wedeen
PHOTOGRAPHER:
Michael Barley, Don Bonsey

"Buzz" words help communicate the unique characteristics of this educational provider. The accordion-fold format represents the flexible nature of the program.

CLIENT:
Mia Torre
DESIGN FIRM:
The Levy Restaurants
Chicago, Illinois
ALL DESIGN BY:
Marcy Lansing Young

To announce a new Italian restaurant, this mailer opens to reveal pieces of information, one panel at a time.

CLIENT:
Interleaf
DESIGNFIRM:
Stoltze Design
Boston, Massachusetts
ART DIRECTOR:
Clifford Stoltze
DESIGNER:
Kyong Choe, Clifford Stoltze

This mailer for new computer software uses bright colors and hard-edged graphics to get attention.

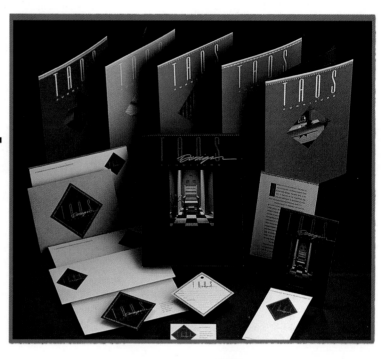

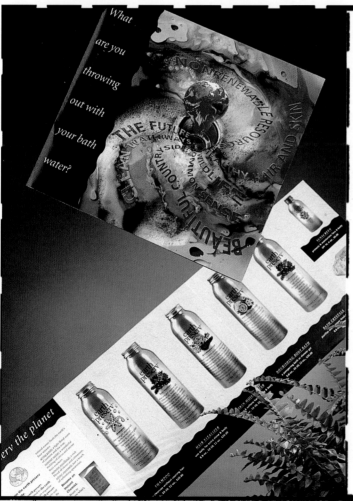

CLIENT:
Earth Preserv
DESIGN FIRM:
Peterson & Company
Dallas, Texas
ART DIRECTOR:
Jan Wilson
DESIGNER:
Jan Wilson, Bryan Peterson
ILLUSTRATOR:
Amy Bryant, Bryan Peterson
PHOTOGRAPHER:
Andy Post

The unusual use of typography makes receipients wonder "what are you throwing out with your bath water?"

CLIENT:
Taos Furniture
DESIGN FIRM:
Vaughn Wedeen Creative
Albuquerque, New Mexico
ART DIRECTOR:
Rick Vaughn
DESIGNER:
Rick Vaughn
PHOTOGRAPHER:
Robert Rick

Consistency is used to advantage in this program for a furniture company. Different colors represent different product lines.

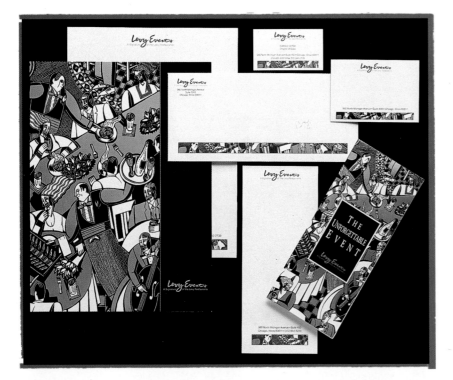

CLIENT:
Levy Events
DESIGN FIRM:
The Levy Restaurants
Chicago, Illinois
CREATIVE DIRECTOR:
Marcy Lansing Young
DESIGNER:
Marcy Lansing Young
ILLUSTRATOR:
Matt Walton

Developed to promote a catering service, this program repeats a single illustration as an element of continuity.

CLIENT:
Boston Design Center
DESIGN FIRM:
Clifford Selbert Design
Cambridge, Massachusetts
ALL DESIGN BY:
Julia Daggett
PHOTOGRAPHER:
Richard Mandelkorn

A self-contained "how-to" package, including a registry of interior designers, provides plenty of information and paves the way for a program of lush mailings that promote design events.

CLIENT:
Cato Design Inc.
DESIGN FIRM:
Cato Design Inc.
Richmond, Victoria, Australia
ALL DESIGN:
Ken Cato

Titled "Edge" this mailer/promotion for an Australian design consultancy has a magazine format. Both graphics and editorial underscore the design and art theme of the piece.

CLIENT:
Park 55 Hotel
DESIGN FIRM:
Sackett Design Associates
San Francisco, California
ALL DESIGN:
Mark Sackett

**A photograph of marble is the foundation
for this hotel promotion. The marble visual
also appears on the envelope.**

CLIENT:
**Hyatt Regency Osaka Wedding/
Banqueting Package**
DESIGN FIRM:
**David Carter Design
Dallas, Texas**
DESIGNER:
Randall Hill
PHOTOGRAPHER:
Klein & Wilson

**This elegant promotion is aimed at
potential wedding/banquet customers
for the Hyatt Regency Osaka.**

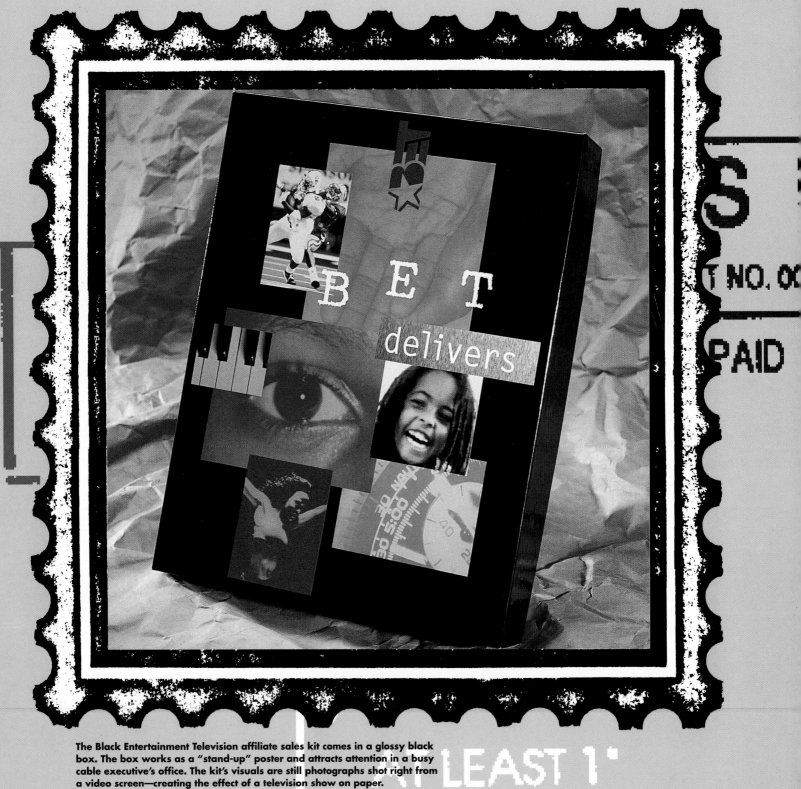

The Black Entertainment Television affiliate sales kit comes in a glossy black box. The box works as a "stand-up" poster and attracts attention in a busy cable executive's office. The kit's visuals are still photographs shot right from a video screen—creating the effect of a television show on paper.

Business-to-Business
Direct Mail

All direct mail has to attract the recipient's attention and get the sender's message across clearly—business-to-business direct mail design faces an additional challenge: multiple "gatekeepers." To be effective, a business mailing must get into the hands of a decision-maker—a person whose mail is commonly screened by a secretary or assistant.

Supon Design Group created an affiliate sales kit for Black Entertainment Television (BET) that not only got through—into the hands of cable company executives—it also helped position BET as a cable network in tune with today's young adults.

Black Entertainment Television is a national cable network based in Washington, D.C. Programming on this rapidly growing network includes entertainment, news, and sports. The company needed a mailing that would convince cable companies nationwide to add BET to their systems. Further, the mailing's design had to demonstrate that BET's programming attracts a large audience with a diverse cultural background.

The atmosphere at BET's studios, and the hip, energetic, video promoting the network's shows impressed Supon's design staff. The designers wanted to capture the colorful, progressive quality of BET's programming in the affiliate sales kit. The result is a video-inspired design with photography shot right from the television screen.

The affiliate sales kit starts with a glossy, black box, shrink-wrapped before mailing to protect its glossy coating in shipping. The box helps the piece get noticed; instead of

TIPS FOR EFFECTIVE DIRECT MAIL DESIGN

1. Be specific.
Format, graphics, photography, and copy all must speak directly to the audience.

2. Strive for balance.
A successful direct mail piece is a good combination of graphics and information. Use graphics to draw the reader in to the mailing, then make sure the information is accessible.

3. Plan ahead.
The look and style of a direct mail piece should be versatile enough for future projects.

getting lost in the shuffle of a busy executive's office, the kit stands out: It looks like a gift. Inside, a spiral-bound pocket folder contains brochures describing BET's programming and performance in various television markets. Different size pockets add visual interest and practicality—they can hold different types of brochures if the kit is up-dated. The pockets also give recipients the option of removing the brochures to a file. Coordinating letterhead allows BET to personalize the kit with information targeted to specific geographic areas. A videotape containing BET programming clips brings the network to life for the recipient.

No location photography was planned for the project, owing to a tight schedule and even tighter budget. This posed a major design challenge, since BET's photo library was limited. The firm's ultimate solution—shooting photgraphy directly from the video screen—is what makes the piece unique. The photographer watched videotapes of

BET programming and shot images he found appealing. These bold, freeze-frame images give the kit the look of a television show on paper.

Since the video screen photographs had a raw, grainy look, BET was at first reluctant to use them. Ultimately, they were convinced—the unexpected graininess of the photos actually gives the kit tremendous appeal and makes the piece more effective.

All design work for the project was done on computer, using Quark and Photoshop programs. By planning ahead, the designers were able to print several components of the mailing on the same print run, which helped save production costs.

According to Supon Design Group, a successful direct mail piece needs to be intriguing enough for the recipient to open it and exciting enough to get immediate response. By this measure, the BET sales kit was a tremendous success: Many of the kit's recipients called the day it arrived to say they liked it and planned to keep it on display. ∎

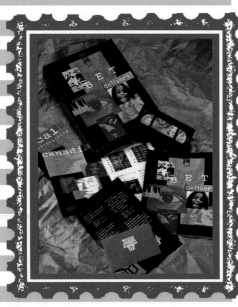

CLIENT:
Black Entertainment Television
DESIGN FIRM:
Supon Design Group, Inc.
Washington, D.C.
ART DIRECTOR:
Supon Phornirunlit, Andrew Dolan
DESIGNER:
Andrew Berman, Richard Boynton
PROJECT DIRECTOR:
Scott Perkins

The entire kit captures the diversity of BET's multicultural audience. Elements of the kit are flexible to allow for future updating.

Not less
Than 1/2"
Between
ZIP Code

Custom letterhead comes with each kit, so information targeted to a specific television market can be added. A videotape featuring BET's programming brings the network to life for the recipient.

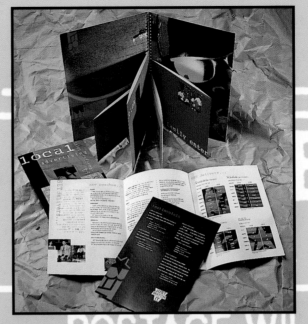

A spiral-bound pocket folder holds brochures containing BET ratings information. The ratings charts use bold graphics and photographic images to draw the eye to these important numbers.

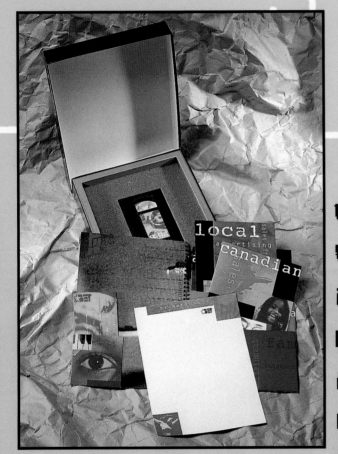

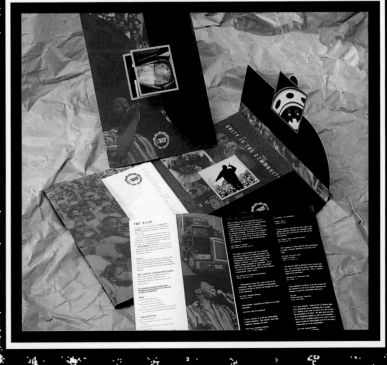

Subsequent BET mailings, such as this promotion for a live event, mirror the graphics and style established in the sales kit.

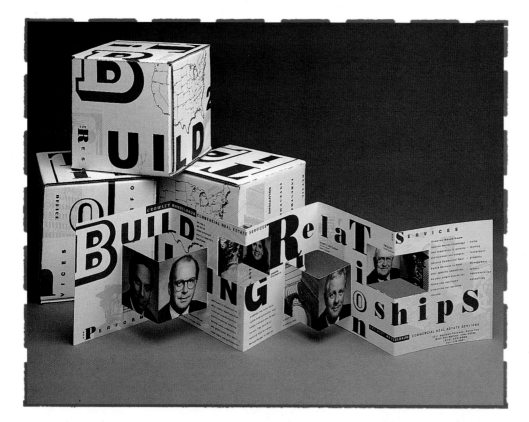

CLIENT:
Crowley Mandelbaum
DESIGN FIRM:
Sayles Graphic Design
Des Moines, Iowa
ALL DESIGN BY:
John Sayles
PHOTOGRAPHER:
Jim Cobb

A 5"x 5"x 5" box attracts attention—the die-cut brochure inside keeps it. The project uses only two colors of ink.

CLIENT:
Berlin Packaging
DESIGN FIRM:
Sayles Graphic Design
Des Moines, Iowa
ALL DESIGN BY:
John Sayles

To introduce a new product—the Pinnacle bottle—the distributor sent out sample bottles to purchasing agents.

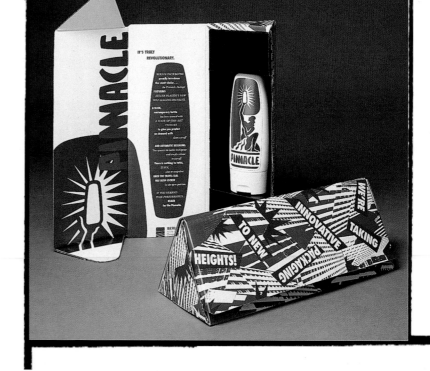

CLIENT:
PPA Design
DESIGN FIRM:
PPA Design
Hong Kong
ALL DESIGN BY:
Byron Jacobs

A holiday card for a Hong Kong design organization, this design wishes recipients both "Merry Christmas" and "Happy Chinese New Year" with an interchangeable visual suited to both greetings.

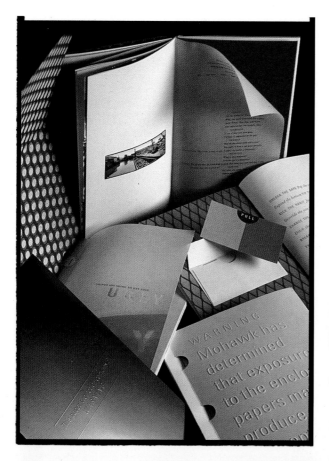

CLIENT:
Mohawk Paper Mills, Inc.
DESIGN FIRM:
Concrete
Chicago, Illinois
DESIGNER:
Jilly Simons, Cindy Chang
COPYWRITER:
Deborah Barran
PHOTOGRAPHER:
Francois Robert

Directed toward graphic designers, this promotion for imported papers employs irony to get attention.

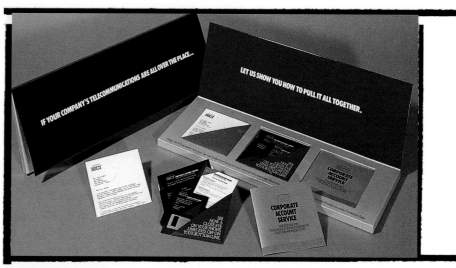

CLIENT:
MCI, Corporate Services Division
DESIGN FIRM:
Barry Blau & Partners N.Y.
Hewlett, New York
ALL DESIGN BY:
Gladys Barton

This impressive mailer arrived in an impressive fashion: It was sent via overnight courier to Fortune 500 executives.

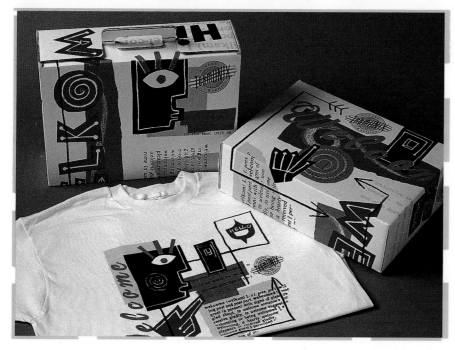

CLIENT:
The Studio Group
DESIGN FIRM:
Sayles Graphic Design
Des Moines, Iowa
ALL DESIGN BY:
John Sayles

A welcome kit developed for this client includes a custom-designed T-shirt.

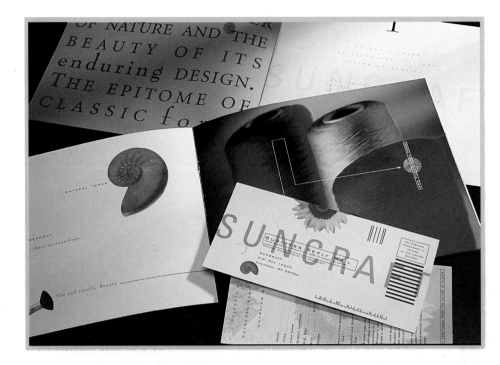

CLIENT:
Shaw Industries
DESIGN FIRM:
Wages Design
Atlanta, Georgia
ART DIRECTOR:
Bob Wages
DESIGNER:
Lisa Reichrath
PHOTOGRAPHER:
Yutaka Kawachi

Taking a simple approach to this direct mail brochure kept costs to a minimun. The design was done entirely on computer, using stock photography.

CLIENT:
Concrete
DESIGN FIRM:
Concrete
Chicago, Illinois
DESIGNER:
Jilly Simons, Susan Carlson
COPYWRITER:
Deborah Barron

Asking "How does it feel to think?", this piece invites the reader to stretch logic taut and create visual associations of their own. The deliberate lack of traditional binding allows all sorts of combinations.

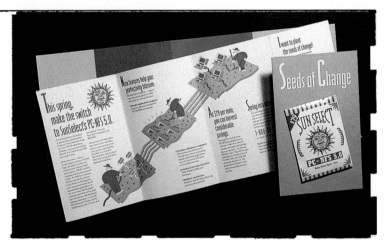

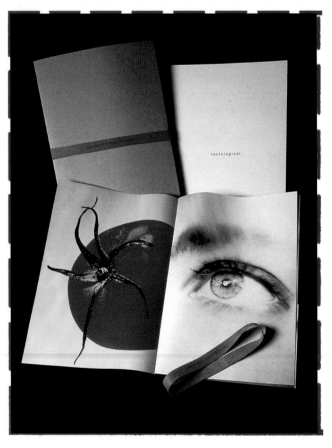

CLIENT:
Sun Microsystems
DESIGN FIRM:
Dickinson Associates
Lexington, Massachusetts
ART DIRECTOR:
Marc English
DESIGNER:
Marc English
ILLUSTRATOR:
James Kraus

The concept for this mailing is based on the products' benefits: Planting this software within one's system generates a harvest of growth and productivity. Illustrations represent the abstract idea of internal connectivity or root systems. A seed packet attached to the front contains real sunflower seeds.

CLIENT:
Color Across America/The Color Center
DESIGN FIRM:
THIRST
Chicago, Illinois
ART DIRECTOR:
Rick Valicenti
DESIGNER:
Rick Valicenti, Mark Rattin

This mailer invites desktop publishers to a hands-on workshop to experience a wide range of computer processes.

CLIENT:
Color Across America/The Color Center
DESIGN FIRM:
THIRST
Chicago, Illinois
ART DIRECTOR:
Rick Valicenti
DESIGNER:
Rick Valicenti
ILLUSTRATOR:
Mark Rattin
PHOTOGRAPHER:
Corrine Pfister, Michael Pappas

This direct mail piece invites desktop publishers to a multi-day workshop on a myriad of subjects— from designing a page to prepress.

CLIENT:
John Cleland
DESIGN FIRM:
Segura Inc.
Chicago, Illinois
ART DIRECTOR:
Carlos Segura
DESIGNER:
Carlos Segura
PHOTOGRAPHER:
Geof Kern

A promotion for a copywriter, this unique booklet is titled "One Thousand Words." Of course, there are exactly 1,000 words of text.

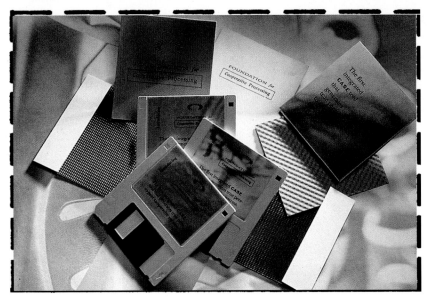

CLIENT:
Arthur Anderson
DESIGN FIRM:
Segura Inc.
Chicago, Illinois
ALL DESIGN BY:
Carlos Segura

A mailing by an accounting firm to introduce a new Software package includes preview disks.

CLIENT:
Dennis Manarchy
DESIGN FIRM:
Bill Sosin Design
Chicago, Illinois
DESIGNER:
Bill Sosin
PHOTOGRAPHER:
Dennis Manarchy

Measuring 13 inches square, this promotion for a photographer features tipped-on (hand applied) images.

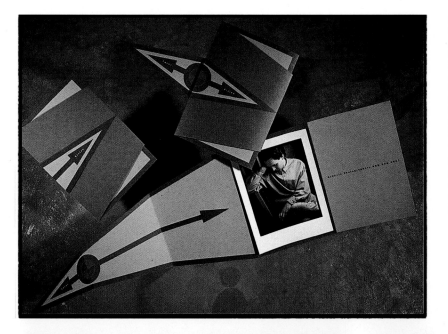

CLIENT:
Rebholz Photographers
DESIGN FIRM:
**Planet Design Company
Madison, Wisconsin**
ART DIRECTOR:
Kevin Wade
DESIGNER:
Kevin Wade, Tom Jenkins
PHOTOGRAPHER:
Mike Rebholz

**This mailer was designed for use in
small batches. Sent to art directors and
other designers, the photographer
would print six to eight of his current
favorite shots in a 5x7 format and tip
them into the housing.**

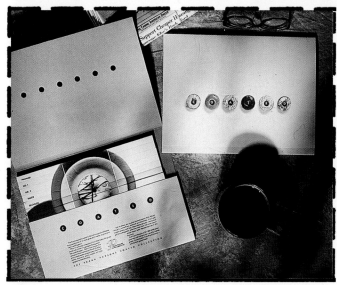

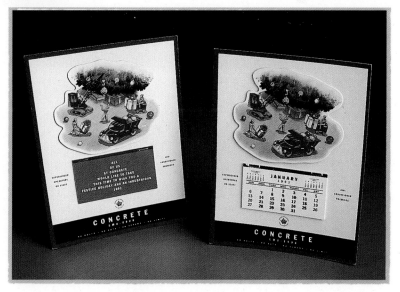

CLIENT:
Frank Parsons Paper Company
DESIGN FIRM:
**Supon Design Group, Inc.
Washington, D.C.**
ART DIRECTOR:
Supon Phornirunlit
DESIGNER:
Andrew Dolan
PHOTOGRAPHER:
Earl Zupkoff

**To demonstrate the flexibility of coated paper,
this mailer included the same image reproduced
27 times—each on a different paper stock.**

CLIENT:
Concrete Design Communications Inc.
DESIGN FIRM:
**Concrete Design Communications Inc.
Toronto, Ontario Canada**
ART DIRECTOR:
John Pylypczak, Diti Katona
DESIGNER:
John Pylypczak, Diti Katona, Ross MacDonald

**Incorporating 1950s-inspired visuals and text, this
calendar/promotion stands up with the help of an
easel backing.**

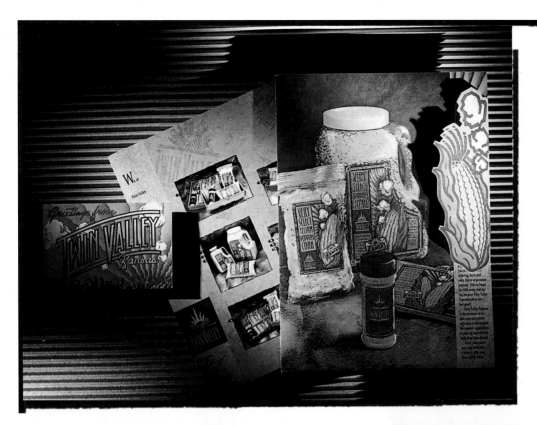

CLIENT:
Twin Valley Popcorn
DESIGN FIRM:
Love Packaging Group
Wichita, Kansas
ALL DESIGN BY:
Tracy Holdeman
PHOTOGRAPHER:
Rock Island Studios

This campaign promotes a popcorn company with postcards, catalog sheets, and a coordinating folder.

CLIENT:
Bradley Printing
DESIGN FIRM:
Liska and Associates, Inc.
Chicago, Illinois
ART DIRECTOR:
Steven Liska
PHOTOGRAPHER:
Scott Morgan

By using a Z-fold, this mailer actually has two covers: one on each side.

CLIENT:
Concrete
DESIGN FIRM:
Concrete
Chicago, Illinois
ART DIRECTOR:
Jilly Simons
DESIGNER:
Jilly Simons, David Robson
IMAGES:
Geof Kern
WORDS:
Deborah Barron

Only 700 of these unique promotions were produced by the design firm. Each was individually numbered.

CLIENT:
Weyerhaeuser
DESIGN FIRM:
Sibley/Peteet Design, Inc.
Dallas, Texas
ALL DESIGN BY:
Don Sibley

The envelope for a paper company's mailing was intentionally designed to get the attention of a group continually bombarded by promotions. As a prelude of things to come, the brochure employs a collection of artifacts with minimal copy.

CLIENT:
Cal. League Service Corp.
DESIGN FIRM:
McMonigle & Spooner
Monrovia, California
ART DIRECTOR:
Stan Spooner
DESIGNER:
Stan Spooner, Jamie McMonigle
ILLUSTRATOR:
Mike Wepplo
PHOTOGRAPHER:
Lyn Martin

This direct mail program takes a modular approach, allowing certain elements to be updated at will.

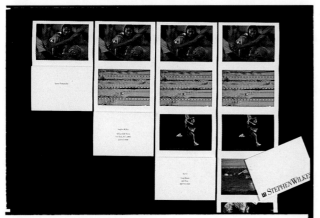

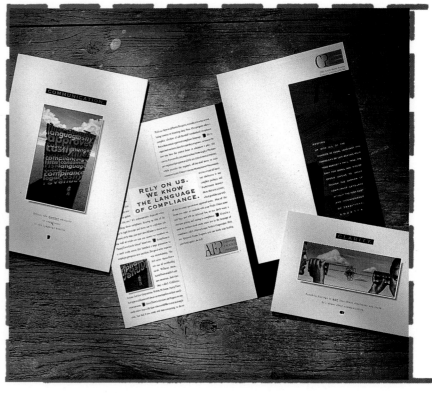

CLIENT:
Stephen Wilkes Photography
DESIGN FIRM:
Liska and Associates, Inc.
Chicago, Illinois
ART DIRECTOR:
Steven Liska
DESIGNER:
Kim Nyberg
PHOTOGRAPHER:
Stephen Wilkes

Showcasing the work of the photographer, this self-promotion unfolds vertically to reveal various images.

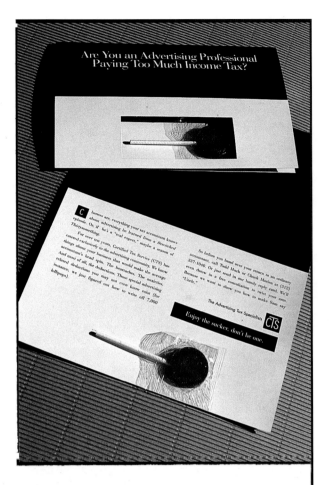

CLIENT:
Certified Tax Specialists
DESIGN FIRM:
Hal Riney & Partners
Chicago, Illinois
ART DIRECTOR:
Paul Janas
DESIGNER:
Paul Janas
WRITER:
William C. Mericle

In a mailing geared to advertising agencies, the punch line to the "Are you paying too much ..." headline is a candy sucker.

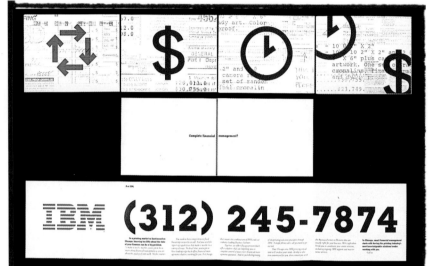

CLIENT:
IBM Corporation
DESIGN FIRM:
Liska and Associates, Inc.
Chicago, Illinois
ART DIRECTOR:
Steven Liska

Directed toward printers in the Chicago area, this brochure speaks their language with a collage of industry terms serving as graphics.

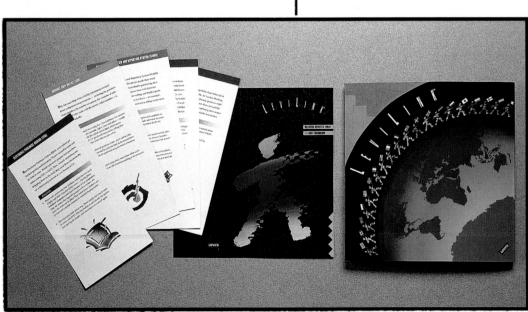

CLIENT:
Levi Strauss & Co.
DESIGN FIRM:
San Yashi Okita Design
San Francisco, California
ART DIRECTOR:
Yashi Okita
DESIGNER:
Han Vu, Liz Omalyev
ILLUSTRATOR:
Kurt Kaufman

Images of the globe and international flags promote an on-line ordering system for a clothing manufacturer.

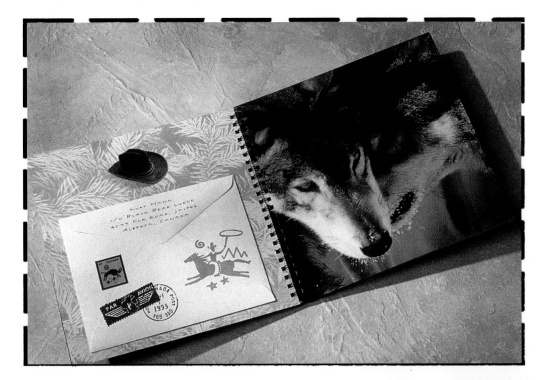

CLIENT:
Rare Indigo
DESIGN FIRM:
HerRainco Design Associates Inc.
Vancouver, BC Canada
ART DIRECTOR:
Casey Hrynkow
DESIGNER:
Deb Kieselbach
PHOTOGRAPHER:
John Sherlock Photography

Real letters are enclosed in the envelopes appearing throughout this mail piece.

CLIENT:
NASDAQ
DESIGN FIRM:
Supon Design Group Inc.
Washington, D.C.
ART DIRECTOR:
Supon Phornirunlit, Andrew Dolan
DESIGNER:
Apisak Saibua

Potential clients can learn more about playing the stock market with the disks included in this mailing. Exercises and games make the learning process fun.

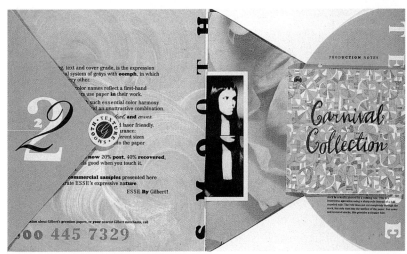

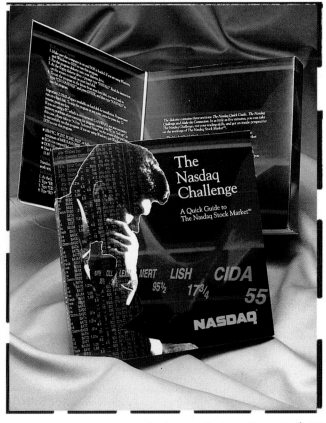

CLIENT:
Gilbert Paper Company
DESIGN FIRM:
Worksight
New York, New York
ALL DESIGN BY:
Scott W. Santoro

Two paper finishes are showcased in this self-mailer for a paper mill. The piece is sealed with an adhesive label sticker.

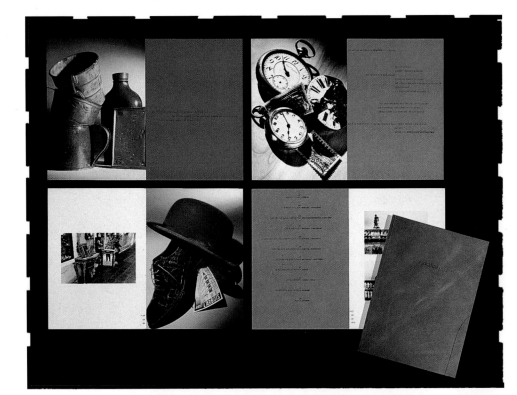

CLIENT:
Craig Cutler Studio
DESIGN FIRM:
Wood Design
New York, New York
ART DIRECTOR:
Tom Wood
DESIGNER:
Tom Wood
PHOTOGRAPHER:
Craig Cutler

Beautiful images, shot both in-studio and on location, form the basis for this sensitive promotion for a photographer.

CLIENT:
MWR Telecom
DESIGN FIRM:
Sayles Graphic Design
Des Moines, Iowa
ALL DESIGN BY:
John Sayles
PHOTOGRAPHER:
Bill Nellans

Designed to resemble a dictionary, this mailer concludes with a pop-up business reply card. Only one color of ink was used to produce the piece.

CLIENT:
LOUIS DREYFUS PROPERTY GROUP
DESIGN FIRM:
WOOD DESIGN
NEW YORK, NEW YORK
ALL DESIGN BY:
TOM WOOD

An elegant promotion for an office building campus, this wire-bound booklet is unique in its use of typography and duotone photographs.

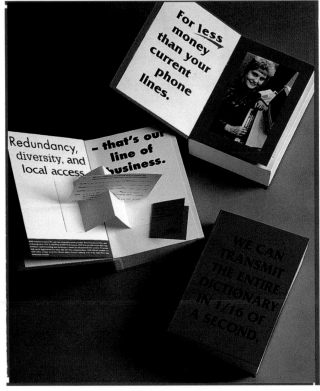

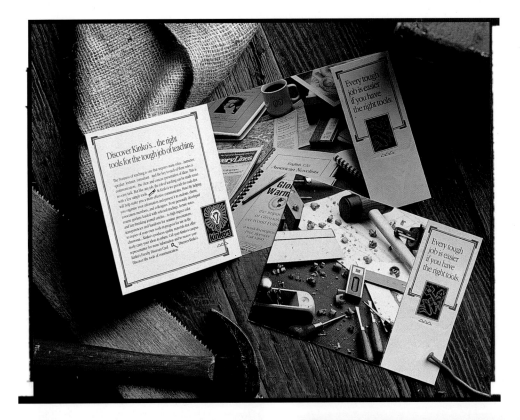

CLIENT:
Kinkos
DESIGN FIRM:
McMonigle & Spooner
Monrovia, California
ART DIRECTOR:
Stan Spooner, Jamie McMonigle
DESIGNER:
Stan Spooner, Jamie McMonigle
ILLUSTRATOR:
Stan Spooner
PHOTOGRAPHER:
Gene Sasse

The "Tools for Teaching" theme of this mailer is underscored with appropriate photography. The four-panel brochure uses a special design, known as a rolling gate fold.

CLIENT:
Concrete Design Communications Inc.
DESIGN FIRM:
Concrete Design Communications Inc.
Toronto, Ontario Canada
ART DIRECTOR:
John Pylypczak, Diti Katona
DESIGNER:
John Pylypczak, Diti Katona, Ross MacDonald

A design firm's promotional mailer includes wire-bound visuals that can be flipped to match the corresponding "calendar."

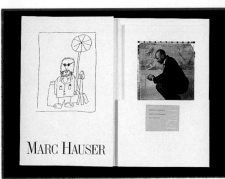

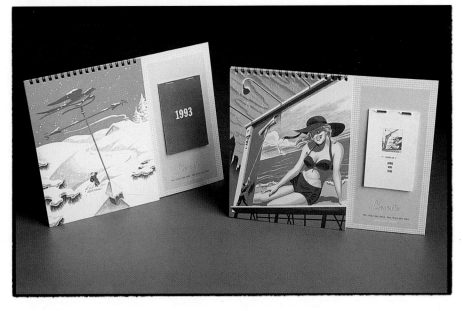

CLIENT:
Marc Hauser Photography
DESIGN FIRM:
Liska and Associates, Inc.
Chicago, Illinois
ART DIRECTOR:
Steven Liska
DESIGNER:
Kim Nyberg
ILLUSTRATOR:
Marc Hauser
PHOTOGRAPHER:
Marc Hauser

This promotional mailing for a photographer features single sheet samples of work, allowing the mailer to be tailored to specific audiences.

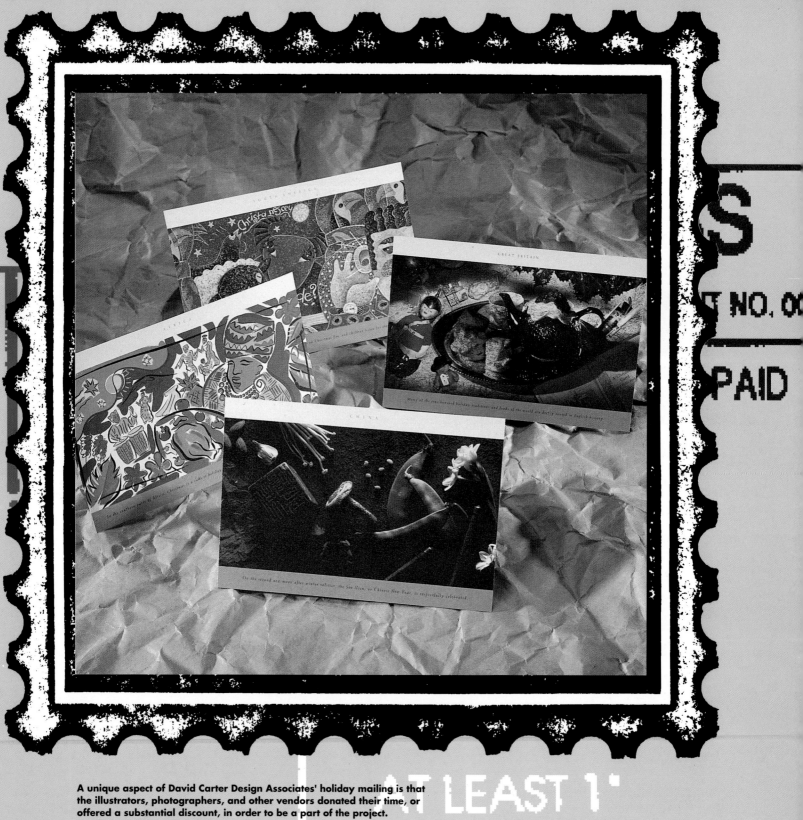

A unique aspect of David Carter Design Associates' holiday mailing is that the illustrators, photographers, and other vendors donated their time, or offered a substantial discount, in order to be a part of the project. Creative credits are included.

Direct Mail
Invitations/
Announcements

The best—and most successful—invitations and announcements present the flavor of the occasion to the recipient. David Carter Design Associates' annual direct mail holiday greeting captures the flavor of the season in an especially literal way.

More than a holiday gift, David Carter Design Associates' greeting also serves as an invitation to their holiday party each year. The unique greetings have an international theme, to appeal to clients and friends worldwide.

Recently, the firm's greeting design centered on an assortment of holiday recipes. A lushly illustrated package and imaginative recipes played on the idea of a holiday feast—both for the appetite and the eyes. The food theme has added appeal because it is universal: Most countries celebrate a holiday that centers around a special meal.

Designer Sharon LeJeune sifted through menus from all over the world, concentrating on countries where her firm had clients. Her recipe choices include a unique variety of foods, such as the French "King Cake"—an almond-flavored cake with a tiny figurine hidden inside. Traditionally, whoever finds the figurine in their piece of cake is adorned with a gold paper crown and proclaimed king (or queen) for the day. Other recipes include Brazilian stuffed banana leaves, and the American favorite, corn bread dressing.

The recipes are printed on oversized cards made of uncoated paper stock. The front of each card has a holiday illustration or photo; descriptive copy about the holiday and the recipe are on the back.

TIPS FOR EFFECTIVE DIRECT MAIL DESIGN

1. **Keep postal regulations in mind.** Postage was the biggest expense for David Carter Design Associates' recipe box mailing.

2. **Keep the outside of a mailing interesting, but physically sturdy and of simple construction to avoid potential damage in the mail.**

For example, the card from Poland features a photograph of shoes on a window sill. At Christmastime, Polish children fill their shoes with hay and leave them on the window sill for St. Nicholas' horse…in hopes the hay will magically be replaced with candy and toys. The South American card contains a colorful illustration of talking farm animals. In Brazil, it is said that animals are given the power of speech on Christmas eve, and children listen for their holiday message.

To make the recipe cards even more of a keepsake—many clients collect the firm's mailings—they're presented in an accordion-pleated chipboard file box. The file's laminated paper cover is a collage of images depicting winter holidays around the world. The box format encourages recipients to add their own favorite recipes to the file and use it year after year.

To save costs, David Carter Design Associates offered to credit illustrators, photographers, and printers in exchange for work done on the mailing. Vendors either donated

their time or offered a substantial discount on services. By offering to print design credit right on the mailer, David Carter Design Associates was able to trade on the mailing's high visibility; it became creative promotional material for everyone involved. The firm took a chance, since using several different illustrators and photographers on a project often doesn't work: The finished product is a collage. In this case, the varied illustration and photographic styles work perfectly to represent the many different countries and holidays in the project. The file box is a cohesive element, bringing all the designs together as a whole.

David Carter Design Associates feels this piece represents their firm well. It's dramatic, yet understated. At a time of year when people are bombarded with mail, this invitation stands out—and it's something recipients will save and enjoy year after year, as a constant reminder of the firm. The firm successfully found a way to make one season's greetings last throughout the other three. ∎

CLIENT/DESIGN FIRM:
David Carter Design Associates
Dallas, Texas
ART DIRECTOR:
David Carter, Lori B. Wilson, Sharon LeJeune
DESIGNER:
Sharon LeJeune
COPY EDITOR:
Bill Baldwin
ILLUSTRATOR:
Michael Crampton, Lynn Rowe Reed, Connie Connally, Rick Smith
PHOTOGRAPHER:
Grace Knott, Dick Patrick, Neal Farris, Ben Britt

An accordion-pleated folder decorated with a collage of holiday images makes the recipe card mailing a keepsake. The piece can be used to hold the recipient's favorite recipes and enjoyed year after year.

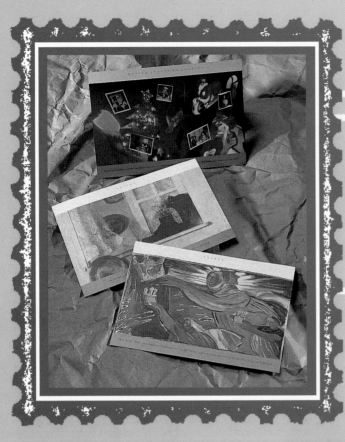

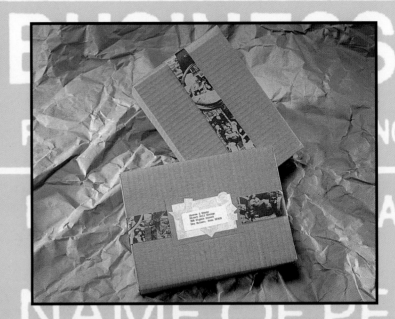

David Carter Design Associates' holiday greeting was mailed in a simple corrugated box. A paper belly-band and mailing label containing holiday images hint at what's inside.

Each card depicts a different country's holiday through visuals and copy explaining the celebration and a traditional recipe.

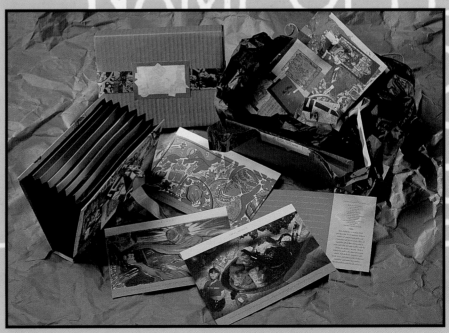

The recipe box was mailed to David Carter Design Associates' clients throughout the world. Locally, it also served as an invitation to the firm's holiday party.

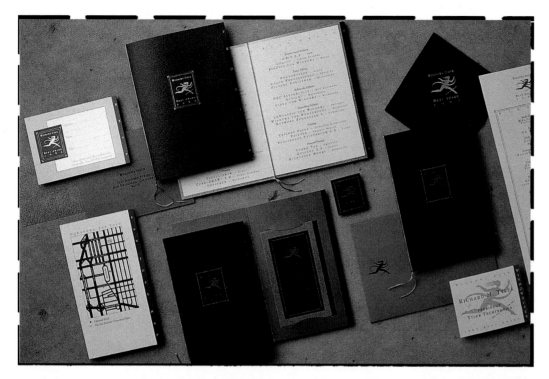

CLIENT:
Windows User Magazine
DESIGN FIRM:
Mauk Design
San Francisco, California
ART DIRECTOR:
Mitchell Mauk
DESIGNER:
Susie Miller

This campaign for a conference of Windows users makes the most of continuity: even the RSVP card bears the program's graphics!

CLIENT:
Harvey Hess
Cedar Falls, Iowa
DESIGNER:
Philip Fass
ILLUSTRATOR:
Philip Fass

Created for a series of chamber concerts held in a private home, this invitation had to be sophisticated, intriguing and—most of all—inexpensive.

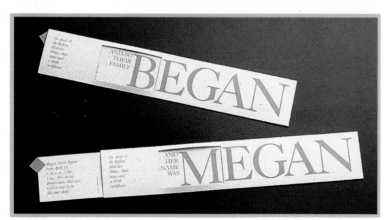

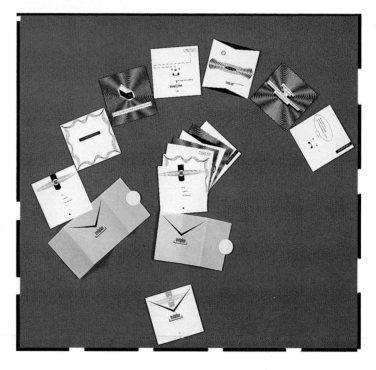

CLIENT:
Jim & Mary Reffett
DESIGN FIRM:
Sackett Design Associates
San Francisco, California
ART DIRECTOR:
Mark Sackett
DESIGNER:
Mark Sackett

A pull-tab works perfectly for this birth announcement, giving the reader cause to reflect.

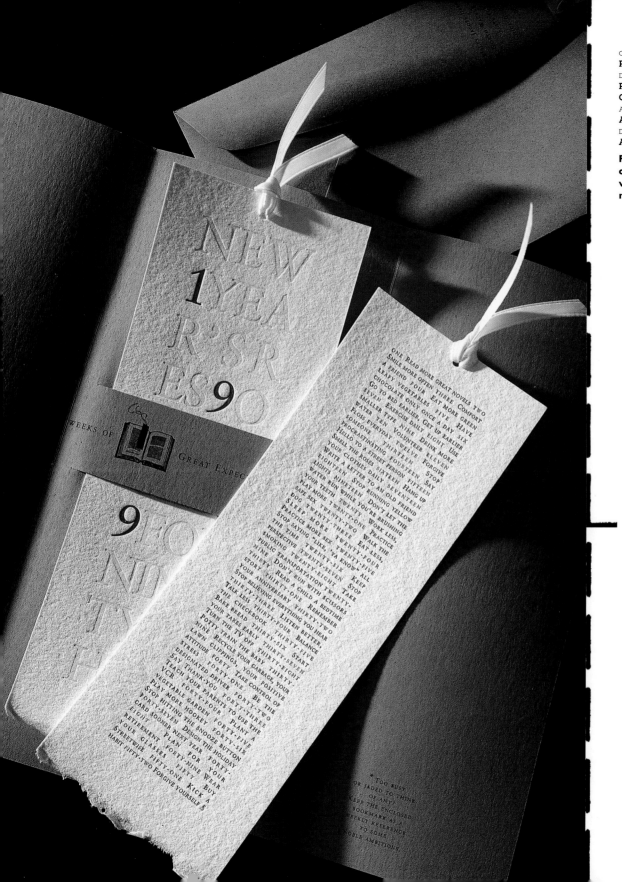

CLIENT:
Pressley Jacobs Design Inc.
DESIGN FIRM:
Pressley Jacobs Design Inc.
Chicago, Illinois
ART DIRECTOR:
Amy W. McCarter
DESIGNER:
Amy W. McCarter

Fifty-two New Year's Resolutions, one for each week in the year, are written on the back of the bookmark included in this mailing.

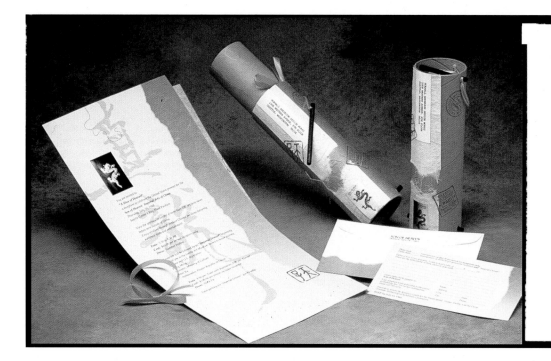

CLIENT:
Son of Heaven Committee
DESIGN FIRM:
Hornall Anderson Design Works
Seattle, Washington
ART DIRECTOR:
Jack Anderson
DESIGNER:
Jack Anderson, Julie Tanagi-Lock
CALLIGRAPHER:
Kenneth Pai

The unique scroll format of this invitation creates an appropriate image for the event: a tour exhibit of Imperial art from China.

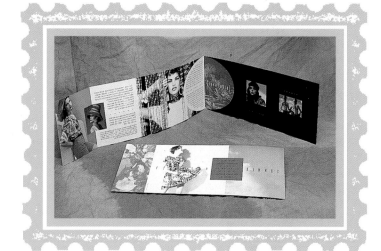

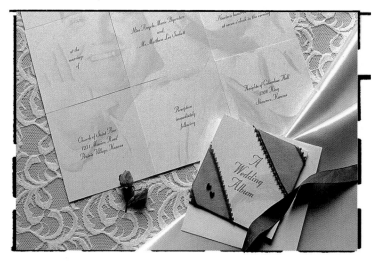

CLIENT:
Miami Merchandise Mart
DESIGN FIRM:
Blue Sky Design
Miami, Florida
ART DIRECTOR:
Maria Dominguez
DESIGNER:
Maria Dominguez

A unique fold-out shape combined with black-and-white and four-color photos attracts immediate attention for this fashion show announcement. The selective use of spot varnish highlights key information.

CLIENT:
Matt & Angela Sackett
DESIGN FIRM:
Sackett Design Associates
San Francisco, California
ART DIRECTOR:
Mark Sackett
DESIGNER:
Mark Sackett
PHOTOGRAPHER:
Hollis Officer Studios

The screened-back photograph in this wedding invitation conveys a feeling of intimacy. Cost-effective to print, the hand-applied ribbon adds an elegant touch.

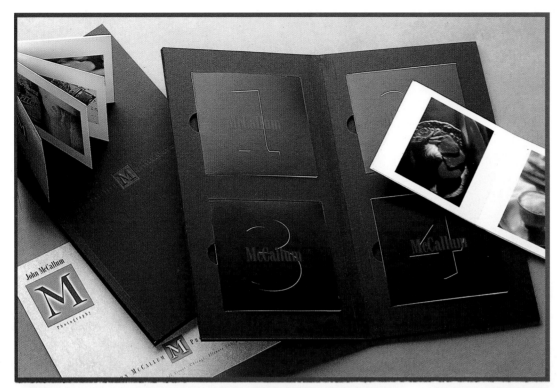

CLIENT:
John McCallum Photography
DESIGN FIRM:
Bill Sosin Design
Chicago, Illinois
DESIGNER:
Bill Sosin
PHOTOGRAPHER:
John McCallum

This photographer's self-promotion included four small portfolios inside a handmade box.

CLIENT:
Zellerbach Paper, Indianapolis
DESIGN FIRM:
Mireille Smits Design
Indianapolis, Indiana
DESIGNER:
Mireille Smits

An invitation to a paper/design show, this mailer effectively uses a traditional business-size envelope.

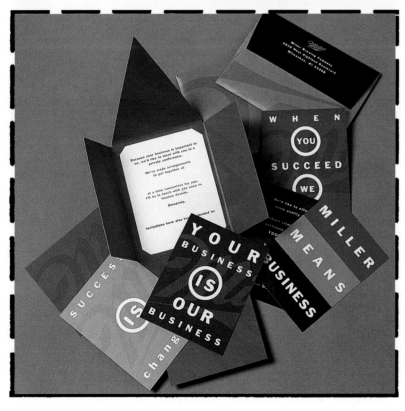

CLIENT:
Miller Brewing Co.
DESIGN FIRM:
Planet Design Company
Madison, Wisconsin
ART DIRECTOR:
Kevin Wade
DESIGNER:
Tom Jenkins

An invitation to a business-building conference sponsored by the Miller Brewing Company, this invitation stressed "success" and emphasized the recipients' business needs.

CLIENT:
American Center for Design
DESIGN FIRM:
Pressley Jacobs Design
Chicago, Illinois
ART DIRECTOR:
Wendy Pressley-Jacobs
DESIGNER:
Susan McQuiddy
ILLUSTRATOR:
Jacki Gelb

Brass rivet binding adds interest to this annual meeting invitation. The illustrations are all done in watercolor.

CLIENT:
Marks/Bielenberg
DESIGN FIRM:
Bielenberg Design
San Francisco, California
ART DIRECTOR:
John Bielenberg
DESIGNER:
Bielenberg Design

Copy is screenprinted on to this announcement's aluminum cover. Inside, single sheet cards are held in place with a key ring.

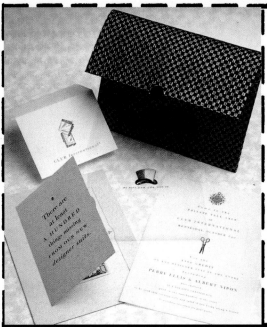

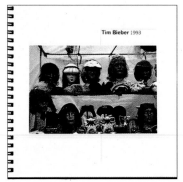

CLIENT:
Club International
DESIGN FIRM:
Segura Inc.
Chicago, Illinois
ART DIRECTOR:
Carlos Segura
DESIGNER :
Carlos Segura

Fine specialty papers lend an air of elegance to this sale announcement.

CLIENT:
Tim Bieber Photography
DESIGN FIRM:
Liska and Associates, Inc.
Chicago, Illinois
ART DIRECTOR:
Steven Liska
DESIGNER:
Matt Brett
PHOTOGRAPHER:
Tim Bieber

Unusual photography can be an effective attention-getter in a mail piece. This wire-bound calendar is a promotion for a photographer.

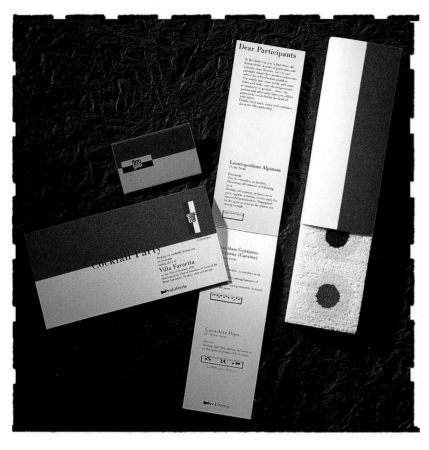

CLIENT:
IFFRO
DESIGN FIRM:
Gottschalk + Ash International
Zurich, Switzerland
DESIGNER:
Fritz Gottschalk, Erich Gross

A follow-up souvenir/mailing (containing seeds of Swiss flowers) was sent to each participant following the Swiss Annual General Meeting in Lugano.

CLIENT:
Weingarten Realty
DESIGN FIRM:
Peat Jariya Design
Houston, Texas
ART DIRECTOR:
Peat Jariya
DESIGNER:
Peat Jariya

This single color invitation demonstrates that effective mailings can be done inexpensively.

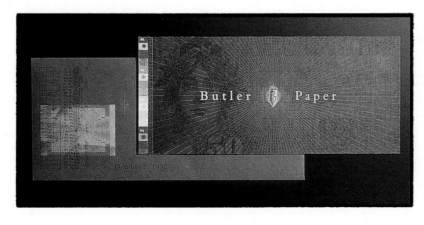

CLIENT:
Butler Paper
DESIGN FIRM:
Louey/Rubino Design Group
Santa Monica, California
ART DIRECTOR:
Regina Rubino, Robert Louey
DESIGNER:
Robert Louey
ILLUSTRATOR:
Joel Nakamura
PHOTOGRAPHER:
Bard Martin, Burton Pritzker

These invitations were printed, scored, engraved, and hand stitched. The envelopes were printed on bright red paper with a silver photo and the date boldly on the front to elicit immediate response.

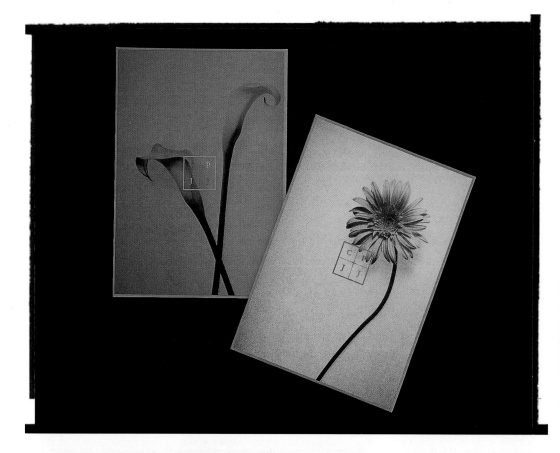

CLIENT:
Colleen Prince
DESIGN FIRM:
Cahan & Associates
San Francisco, California
ART DIRECTOR:
Bill Cahan
DESIGNER:
Jean Orlebeke
PHOTOGRAPHER:
Jean Orlebeke

This wedding invitation features a modular design that lets the couple send out different cards for each function.

CLIENT:
Haagen Printing
DESIGN FIRM:
Puccinelli Design
Santa Barbara, California
ART DIRECTOR:
Keith Puccinelli
DESIGNER:
Keith Puccinelli, Heidi Palladino
ILLUSTRATOR:
Keith Puccinelli

Late into the design process, the client suggested including a photocopied map in this invitation so out-of-towners could find the seminar. The design firm had a better idea.

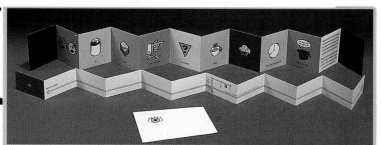

CLIENT:
Mr. & Mrs. Gary Resnick
DESIGN FIRM:
THIRST
Chicago, Illinois
DESIGNER:
Rick Valicenti

"Old World" and "unique" were the clients' two requests for their son and daughter's Bar and Bat Mitzvah invitations. Copy was letterpressed in both English and Hebrew on Rives BFK paper.

50 Creative Direct Mail Design

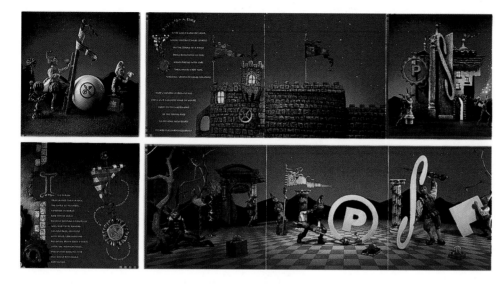

CLIENT:
Pittard Sullivan Fitzgerald
DESIGN FIRM:
Pittard Sullivan Fitzgerald
Hollywood, California
ART DIRECTOR:
Billy Pittard, Ed Sullivan, Wayne Fitzgerald
DESIGNER:
Frances Schifrin
ILLUSTRATOR:
Frances Schifrin, Keith Mitchell
PHOTOGRAPHER:
Joel Lipton

To bring recipients into a magical world where "wonderful graphics are created," this mailing uses hi-tech composting and miniatures.

CLIENT:
Editel/Chicago
DESIGN FIRM:
THIRST
Chicago, Illinois
ART DIRECTOR:
Rick Valicenti
DESIGNER:
Rick Valicenti
ILLUSTRATOR:
THIRST

Recognizable landmarks distinguish this mailer from others created for Editel offices nationwide. This series of three direct mailers pairs simplistic copy with sophisticated computer imagery in the hopes of provoking an audience response.

CLIENT:
Hopper Papers
DESIGN FIRM:
Wages Design
Atlanta, Georgia
ART DIRECTOR:
Ted Fabella, Bob Wages
DESIGNER:
Ted Fabella
PHOTOGRAPHER:
Raquel C. Miqueli

An invitation to participate in a paper company event, this mail piece uses unusual halftone photographs to spell the name of the event.

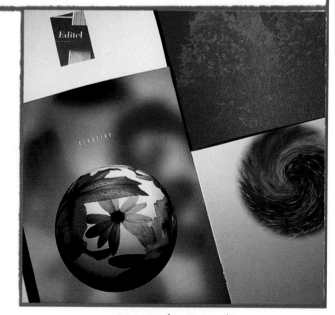

Direct Mail Invitations/Announcements 51

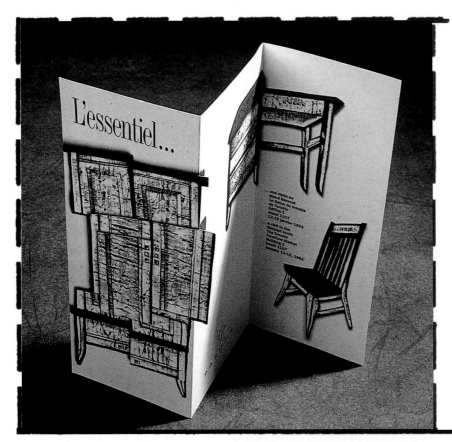

CLIENT:
Baronet
DESIGN FIRM:
PAPRIKA
Montréal, Québec Canada
ART DIRECTOR:
Louis Gagnon
DESIGNER:
Louis Gagnon
ILLUSTRATOR:
Gérard

Strategically placed dies bring this mailer to life. It was developed to promote a new line of furniture.

CLIENT:
Towers Perrin
DESIGN FIRM:
Towers Perrin
Chicago, Illinois
ART DIRECTOR:
Jim Kohler
DESIGNER:
Jeanmarie Powers
ILLUSTRATOR:
Linda Betzold

Screen-printed in order to create additional texture, this invitation includes individual information cards. Each card bears a different illustration.

CLIENT:
Geffen Records
ALL DESIGN BY:
Kevin Reagan
Los Angeles, California

A simple illustration and bright colors team up to make recipients respond to this invitation.

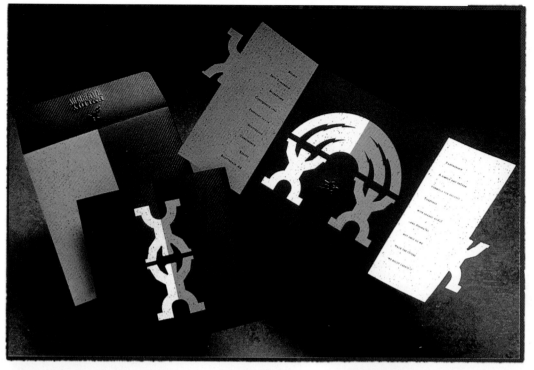

CLIENT:
Food Services of America
DESIGN FIRM:
**Hornall Anderson Design Works
Seattle Washington**
ART DIRECTOR:
Jack Anderson
DESIGNER:
**David Bates, Jack Anderson,
Cliff Chung, Jani Drewfs**
ILLUSTRATOR:
David Bates, Brian O'Neill

Strong visuals on a conference invitation hint at its topic: building and bridging partnerships.

CLIENT:
Peter Lord & Elizabeth Carlucoo-Lord
DESIGN DIRECTOR:
Peter Lord
DESIGNER:
Elizabeth Carlucoo-Lord

The vellum envelope for this wedding invitation is actually sewn closed. Inside, two different cards, one inscribed "I will be attending," the other, "I won't ..." invite reply.

CLIENT:
Premisys Real Estate
DESIGN FIRM:
**Sibley/Peteet Design, Inc.
Dallas, Texas**
ART DIRECTOR:
Rex Peteet
DESIGNER:
Diana McKnight
ILLUSTRATOR:
Diana McKnight

The die-cut accordion-fold mailer juxtaposed a classic, sentimental symbol of home and family. Void of color, the card makes a simple but elegant statement.

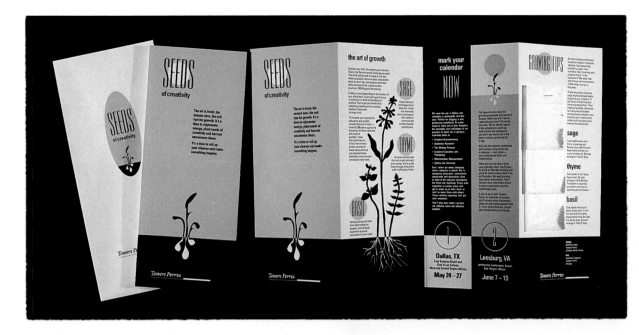

CLIENT:
Towers Perrin
DESIGN FIRM:
**Towers Perrin
Chicago, Illinois**
ART DIRECTOR:
Kathleen Aiken
DESIGNER:
Kathleen Aiken

To underscore the "Seeds of Creativity" theme of this mailing, the last panel holds . . . seeds!

CLIENT:
Cato Design Inc.
DESIGN FIRM:
**Cato Design Inc.
Richmond, Victoria Australia**
ART DIRECTOR:
Ken Cato
DESIGNER:
Andrew Stumpfel
ILLUSTRATOR:
Andrew Stumpfel

A decidedly unconventional approach to a Christmas card, this mailer uses just one color of ink.

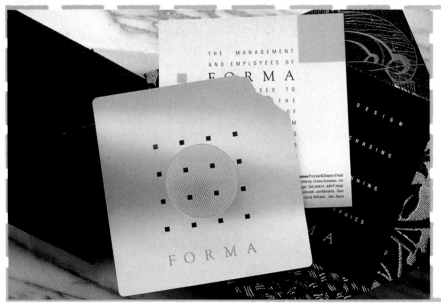

CLIENT:
FORMA
DESIGN FIRM:
**Hornall Anderson Design Works
Seattle, Washington**
ART DIRECTOR:
John Hornall
DESIGNER:
John Hornall, David Bates

Designed to announce an acquisition in a clever and memorable manner, this announcement was chemically-etched on stainless steel.

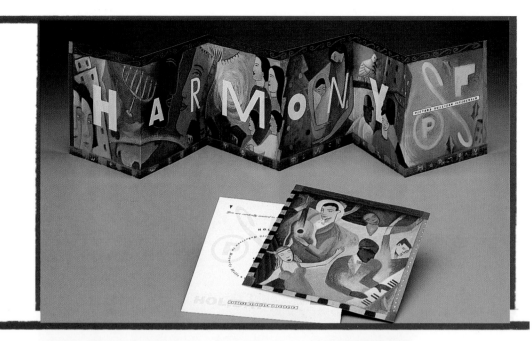

CLIENT:
Pittard Sullivan Fitzgerald
DESIGN FIRM:
Pittard Sullivan Fitzgerald
Hollywood, California
ART DIRECTOR:
Billy Pittard, Ed Sullivan, Wayne Fitzgerald
DESIGNER:
Curt Doty
ILLUSTRATOR:
Curt Doty

A greeting sent by a Los Angeles-based design firm to its entertainment industry clientele promotes the theme of harmony among the peoples and cultures of the world.

CLIENT:
Polaroid
DESIGN FIRM:
Moore Moscowitz
Boston, Massachusetts
ART DIRECTOR:
Tim Moore
DESIGNER:
Jan Moscowitz, Annette Sieblitz
PHOTOGRAPHER:
Clark Quin

The reply card for this unusual invitation comes with a vellum envelope, making the reply visible before the envelope is opened.

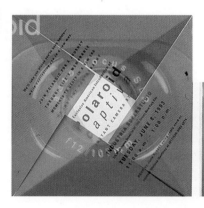

CLIENT:
Hornall Anderson Design Works
DESIGN FIRM:
Hornall Anderson Design Works
Seattle, Washington
ART DIRECTOR:
Jack Anderson, John Hornall
DESIGNER:
Jack Anderson, John Hornall, Julie Tanagi-Lock
ILLUSTRATOR:
Julie Tanagi-Lock

Sheet metal took this invitation out of the realm of the ordinary and helped capture the immediate attention of recipients. The beach party theme generated a spirit of celebration for the late summer open house.

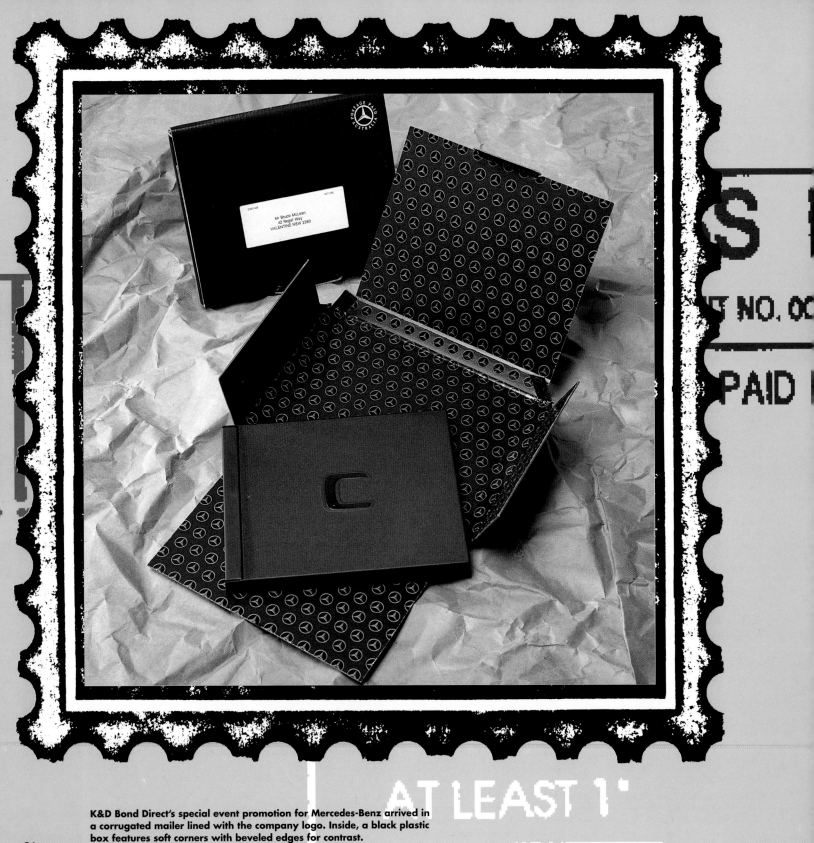

K&D Bond Direct's special event promotion for Mercedes-Benz arrived in a corrugated mailer lined with the company logo. Inside, a black plastic box features soft corners with beveled edges for contrast.

Direct Mail
Special Event Promotions

Successful special events take a lot of time and effort to plan and execute. The same goes for successful mailings that promote special events. Whether the function is a party, an awards ceremony, a fundraiser or a sale, there is but one goal for the direct mail promotion—get people to the event. Good special event mailings entice; they present the event's atmosphere and build excitement around it.

The launch of a completely new Mercedes-Benz model is a rare occasion indeed. Past model launches were famous for their extravagance. When the car manufacturer decided to pursue a gentler, more responsible image, they needed to attract buyers to the new low-key events. As part of the launch for Mercedes' new C-Class model to Australian dealerships, K&D Bond Direct created a

mailing that reflects the qualities of the car itself—sophisticated and powerful. Mercedes buyers are predisposed to quality. They expect it and are reassured by it. K&D Bond Direct's mailing was successful because it so accurately "spoke" to the Mercedes customer. The launch received nearly triple the response expected, and as a result, Mercedes-Benz dealerships reported over 38 million dollars in car sales.

K&D Bond Direct's design goal was to create immediate interest in Mercedes-Benz and a favorable impression of the car. To achieve it, they put wildlife in a box. Mercedes-Benz customers and prospects opened their mailboxes to find an understated box of corrugated black paper. Inside, the box is lined with a pattern of Mercedes-Benz logos, printed in varnish. A streamlined

TIPS FOR EFFECTIVE DIRECT MAIL DESIGN

1. **Know your audience.**
 Ask yourself: Does the design reflect the product? Will the audience relate to it?

2. **Know the client.**
 What needs does the mailing have to satisfy?

3. **Get through.**
 What will make your audience open the box and read the information? What will make them respond?

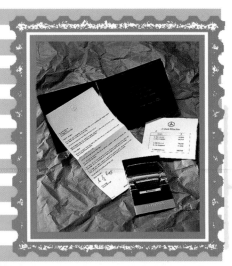

Designed to increase the recipient's curiosity as each "layer" of the mailing unfolded, the package revealed—a black plastic box, a cover letter, an invitation, and a wire-bound brochure. A Mercedes price list was also included.

plastic case embossed with the letter C reveals a brief, personalized cover letter spotlighting the launch event and the car. A wire-bound brochure expresses the power of the C-Class with colorful photographs of wildlife. A personalized fold-out brochure invites the customer to attend the launch and test drive the car.

Though their approach is not overtly automotive, K&D Bond Direct's designers felt the wildlife motif best conveyed their message. Photo-graphs and quotes describe the car's features warmly and gently, tapping into consumer values regarding nature and the environment. Black ink backgrounds with matte varnish set the images off from the rest of the page. Quotes link animal images to specific attributes of the car; 'menacing power' is reinforced by a photograph of a lion, for example. Copy on a subsequent page describes the C-Class engine.

By using wildlife, K&D Bond Direct was able to do something quite out of the mold for Mercedes, yet still deliver the style and panache people expect from the brand. Wildlife also tied in with two contests offered to those who took a test drive at a

dealership. Contestants could win an African safari trip or an Australian wilderness adventure.

Part of K&D Bond Direct's success came from the strength of the photography they chose. The designers sourced animal photography from around the world—sifting through thousands of transparencies to find images that captured the spirit of the car.

The hard work paid off. The Mercedes-Benz special event promotion surpassed the response goals of both the agency and the client. The mailing generated excitement among customers and within the whole Mercedes-Benz organization. The promotion was ground-breaking; to the best of Mercedes-Benz' knowledge no other Australian car manufacturer got as much response to a new model launch. As the barriers between general advertising and direct marketing disappear, companies strive to create image and awareness at the same time. A classic example of integrated marketing, K&D Bond Direct's special event promotion did both. Their cost-effective strategy got dramatic results; their direct mail piece represents the

Not less
Than 1/2"
Between
ZIP Code

In the wire-bound brochure, artsistic images of wildlife allude to the attributes of the Mercedes-Benz C-Class model.

CLIENT:
Mercedes-Benz Australia
AGENCY:
K&D Bond Direct
Sydney, Australia
ART DIRECTOR:
Bruce Bennett
COPYWRITER:
Peter Keeble
PRODUCTION MANAGER:
Philip Edel
ACCOUNT MANAGER:
Karl Vogel

A personalized invitation ceremoniously invites the recipient to a launch event at their local Mercedes dealership.

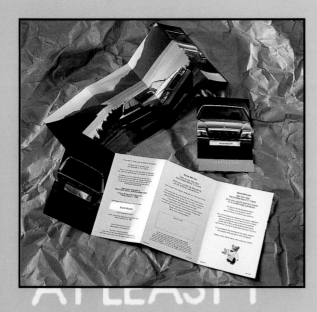

The entire mailing unveiled. From package to image, Mercedes-Benz' special events promotion expressed luxury. Recipients responded in unprecedented numbers.

CLIENT:
Manzano Day School
DESIGN FIRM:
Vaughn Wedeen Creative
Albuquerque, New Mexico
ART DIRECTOR:
Steve Wedeen
DESIGNER:
Steve Wedeen
ILLUSTRATOR:
Vivian Harder, Stan McCoy

This calendar was conceived as a fund-raiser for a private nonprofit school. The revenue/sponsorship objectives are incorporated with educational and informational content including school events, daily trivia and quotes.

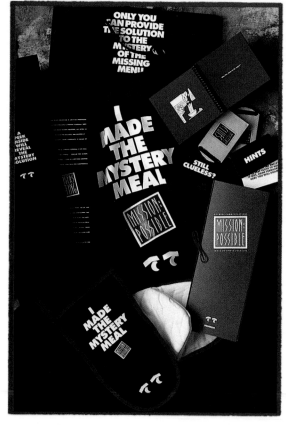

CLIENT:
U.S. West Communications
DESIGN FIRM:
Vaughn Wedeen Creative
Albuquerque, New Mexico
ART DIRECTOR:
Steve Wedeen
DESIGNER:
Steve Wedeen

Shown here are teasers, mailings, and gifts relating to an annual sales meeting. By limiting the number of colors used in the mailing, the design budget could be stretched to include interesting premiums.

CLIENT:
New England Direct Marketing
 Association
AGENCY:
IQ&J Group 121
Boston, Massachusetts
ART DIRECTOR:
John Gonnella
COPYWRITER:
Greg Crozier
PHOTOGRAPHER:
Bill Miles

This award show entry form was developed to solicit entries to the competition as well as overall interest in the association.

CLIENT:
I.E.A.C.
DESIGN FIRM:
McMonigle & Spooner
Monrovia, California
ART DIRECTOR:
Jamie McMonigle, Stan Spooner
DESIGNER:
Jamie McMonigle, Stan Spooner
ILLUSTRATOR:
Stan Spooner

This intricate "Call for Entries" looks innocent enough on the outside, but once it's opened the recipient discovers a myriad of die-cuts and special effects.

CLIENT:
Equitable of Iowa
DESIGN FIRM:
Sayles Graphic Design
Des Moines, Iowa
ALL DESIGN BY:
John Sayles

A miniature toolbox-shaped mailer tells recipients "Congratulations . . . you've measured up."

CLIENT:
WCVB TV Boston
DESIGN FIRM:
WCVB TV Design
Lexington, Massachusetts
ART DIRECTOR:
Marc English
DESIGNER:
Marc English

A humorous, memorable, and functional mailing for a TV station plays off a popular television show. Two note pads are involved: one is complete with coffee stains and a lipstick smudge; the other is die-cut in the shape of a woman—presumably deceased.

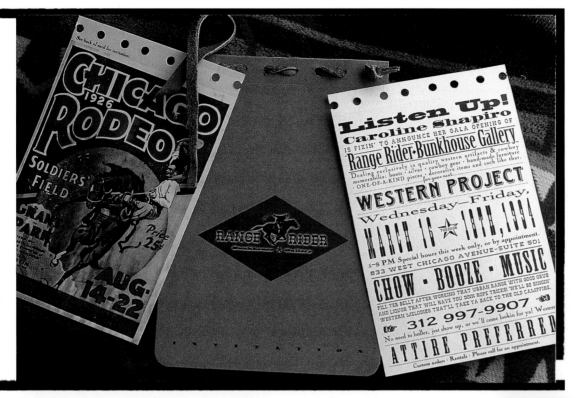

CLIENT:
Range Rider Bunkhouse Gallery
DESIGN FIRM:
Bill Sosin Design
Chicago, Illinois
DESIGNER:
Bill Sosin

A portfolio approach to direct mail, this gallery opening announcement uses a buckskin paper for its outside cover.

CLIENT:
Adventure Lighting
DESIGN FIRM:
Sayles Graphic Design
Des Moines, Iowa
ALL DESIGN BY:
John Sayles

This moving announcement stands two-feet tall and includes a removable business card with the new company address.

CLIENT:
Wichita Collegiate School
DESIGN FIRM:
Love Packaging Group
Wichita, Kansas
ART DIRECTOR:
Tracy Holdeman, Brian Miller
DESIGNER:
Tracy Holdeman, Brian Miller
ILLUSTRATOR:
Tracy Holdeman

This two-part piece consists of a teaser and an invitation to a high school's Founder's Day Celebration. The graphic-style relates to 1963, the date the school was founded.

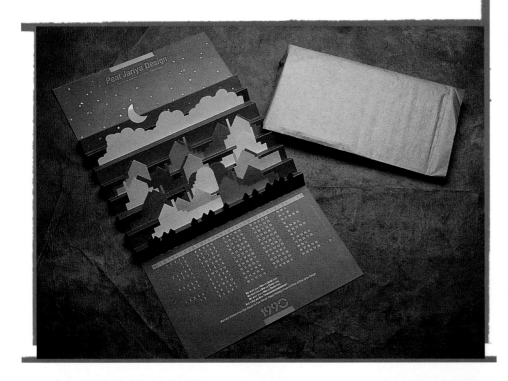

CLIENT:
Kaufman Meeks Architects
DESIGN FIRM:
Peat Jariya Design
Houston, Texas
ART DIRECTOR:
Peat Jariya
DESIGNER:
Peat Jariya

A unique three-dimensional calendar is created by using dies and a series of folds.

CLIENT:
Takeo Co., Ltd.
DESIGN FIRM:
Nippon Design Center
Chiyoda-Ku, Tokyo
ALL DESIGN BY:
Kenya Hara

A tissue paper liner adds a simple, elegant touch to this invitation for the annual Takeo Paper World exhibition. The main portion of the mailer is printed in red, black, and gold, the insert is blue and black.

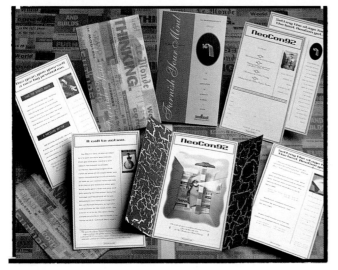

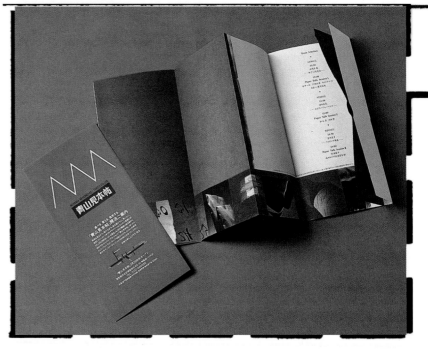

CLIENT:
Merchandise Mart
DESIGN FIRM:
Segura Inc.
Chicago, Illinois
ALL DESIGN BY:
Carlos Segura
PHOTOGRAPHER:
Geof Kern

An internal mailing to tenants of the Merchandise Mart previews an event being held in the building.

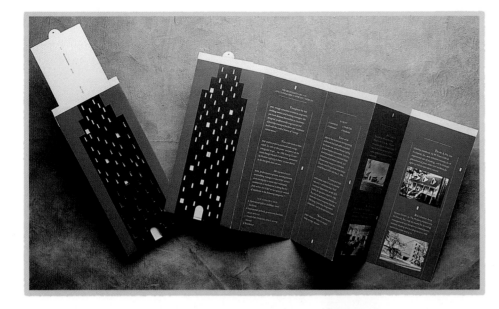

CLIENT:
HL&P
DESIGN FIRM:
Peat Jariya Design
Houston, Texas
ART DIRECTOR:
Peat Jariya
DESIGNER:
Peat Jariya

This promotion for an energy conservation program gets the point across clearly: Pull the tab and the building goes dark.

CLIENT:
David Carter Design Associates
DESIGN FIRM:
David Carter Design Associates
Dallas, Texas
ART DIRECTOR:
David Carter, Lori B. Wilson
DESIGNER:
Brian Moss
ILLUSTRATOR:
Connie Connally

A textural and pretty holiday promotion, this mailing uses several different kinds of paper stock. Thread-binding adds an interesting touch.

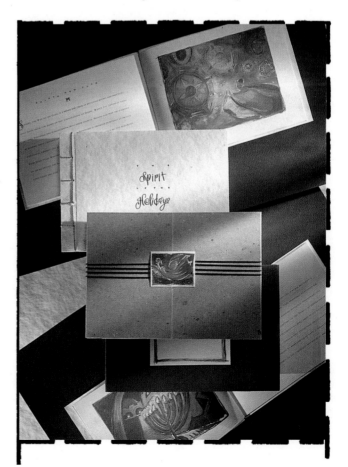

CLIENT:
The Wyatt Company
DESIGN FIRM:
Pressley Jacobs Design
Chicago, Illinois
ART DIRECTOR:
Wendy Pressley-Jacobs
DESIGNER:
William Lee Johnson
PHOTOGRAPHER:
Frank Miller

This calendar/planner was distributed to clients and employees. The calendar's theme, "People with Vision," pays tribute to the men and women who have been great leaders in 20th century America.

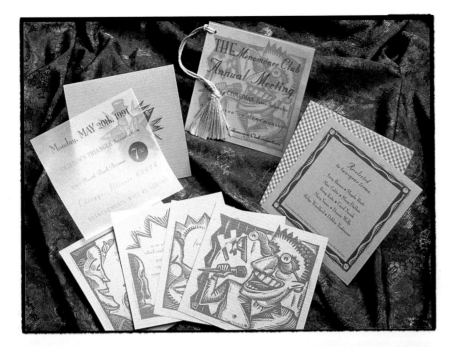

CLIENT:
Menomonee Club
DESIGN FIRM:
Segura Inc
Chicago, Illinois
ART DIRECTOR:
Carlos Segura
DESIGNER:
Carlos Segura
ILLUSTRATOR:
Mary Flock Lempa

Scratch board illustrations lend a light touch to this invitation. Individual sheets are drilled in one corner and held in place with a tassel.

CLIENT:
AIGA Minnesota
DESIGN FIRM:
Design Ahead
Minneapolis, Minnesota
ART DIRECTOR:
Kristen LaFavor
DESIGNER:
Kristen LaFavor, Thea Tulloss
ILLUSTRATOR:
Lynn Tanaka
PHOTOGRAPHER:
Mark LaFavor

An invitation devised to entice graphic designers to attend a special "Design Camp" used pine cones and other natural objects to reinforce the theme.

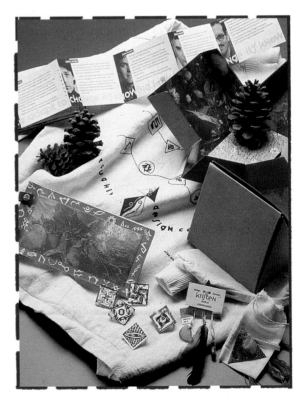

CLIENT:
Merchandise Mart
DESIGN FIRM:
Segura Inc.
Chicago, Illinois
ART DIRECTOR:
Carlos Segura
DESIGNER:
Carlos Segura

The headline for this mailer reads "If you come to Chicago in January, you're either a little crazy, or very gifted." The invitation is for the Chicago Gift and Accessories Market.

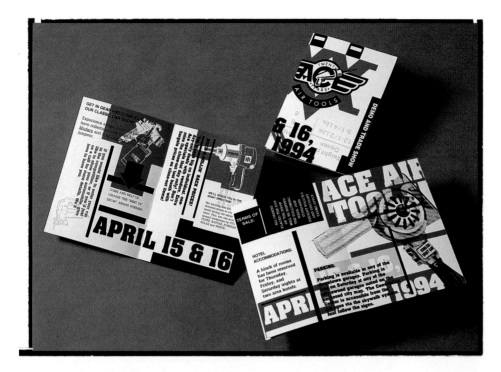

CLIENT:
Ace Air Tools
DESIGN FIRM:
Sayles Graphic Design
Des Moines, Iowa
ALL DESIGN BY:
John Sayles

Visuals for this event promotion were taken from the company's catalog. This provides low-cost, product-driven artwork.

CLIENT:
MRSA Architects
DESIGN FIRM:
Segura Inc
Chicago, Illinois
ART DIRECTOR:
Carlos Segura
DESIGNER:
Carlos Segura

Boxes of paddles found in an alley became an intriguing—and low-cost—New Year's announcement for an architect's firm.

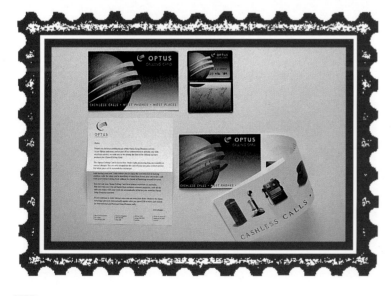

CLIENT:
Optus Communications
AGENCY:
K & D Bond Direct
Sydney, Australia
ART DIRECTOR:
Bruce Bennett, Peter Keeble

"Cashless calls: most phones, most places," is the theme for this Australian calling card promotional mailer. A variety of telephones are shown to reinforce the concept.

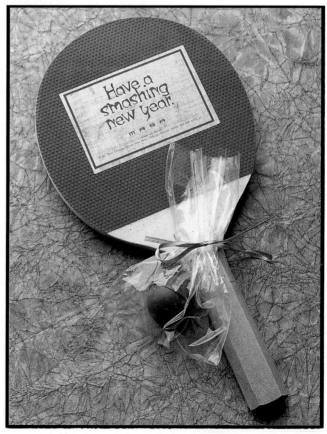

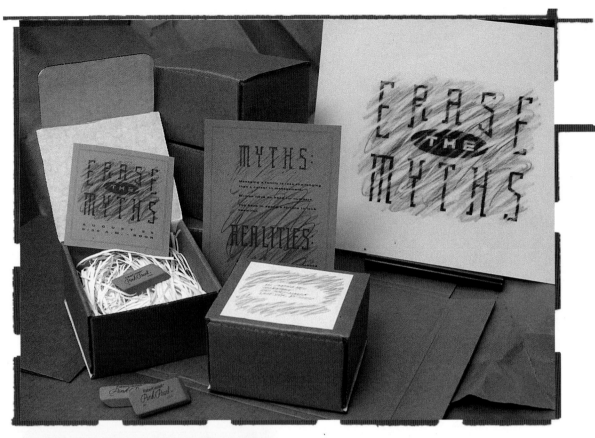

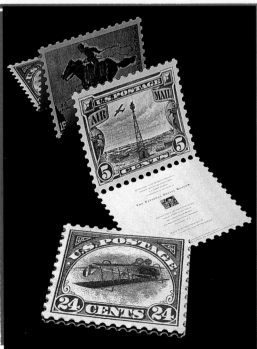

CLIENT:
Helene Curtis/Golin Harris
DESIGN FIRM:
**Steve Meek Incorporated
Chicago, Illinois**
ALL DESIGN BY:
Steve Meek

**Everyone who receives a box will open it.
This one was also hand addressed and
therefore very appealing.**

CLIENT:
Hines Interests Limited Partnership
DESIGN FIRM:
**Rigsby Design, Inc.
Houston, Texas**
ART DIRECTOR:
Lana Rigsby
DESIGNER:
Lana Rigsby, Michael B. Thede

**This invitation promotes the grand opening
of the National Postal Museum at the
Smithsonian Institution in Washington,
D.C. The oversized piece is mailed out in
the same glassine envelopes the Postal
Service uses to hold sheets of stamps.**

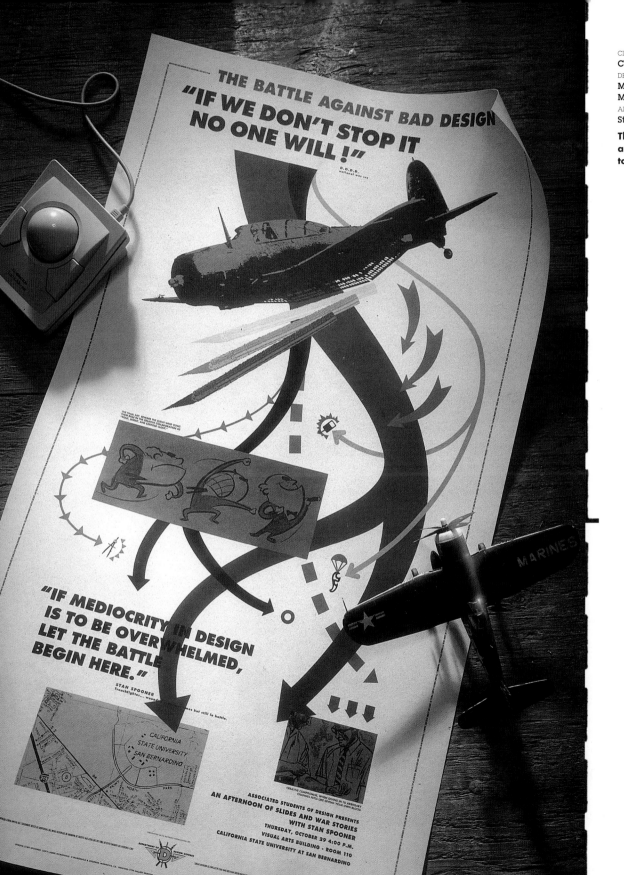

CLIENT:
California State San Bernardino
DESIGN FIRM:
McMonigle & Spooner
Monrovia, California
ALL DESIGN BY:
Stan Spooner

This poster-mailer promotes a talk by a design veteran to college-age students.

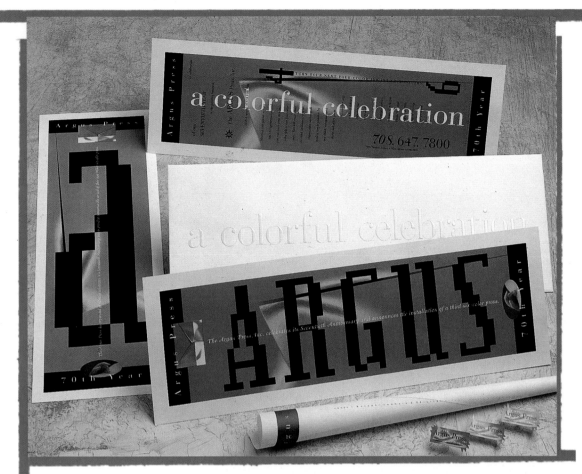

CLIENT:
Argus Press
DESIGN FIRM:
Segura Inc.
Chicago, Illinois
ART DIRECTOR:
Carlos Segura
DESIGNER:
Carlos Segura
PHOTOGRAPHER:
Montresor

This oversized mailer arrives in a white envelope embossed with the words "A Colorful Celebration." Inside, the printer makes good on the promise of color and announces a 70th anniversary event.

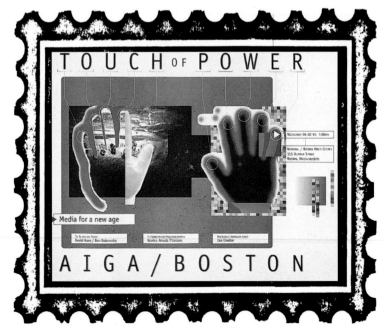

CLIENT:
AIGA/Boston
DESIGN FIRM:
Marc English: Design
Lexington, Massachusetts
ALL DESIGN BY:
Marc English

This poster was mailed to promote a panel discussion by interactive video professionals.

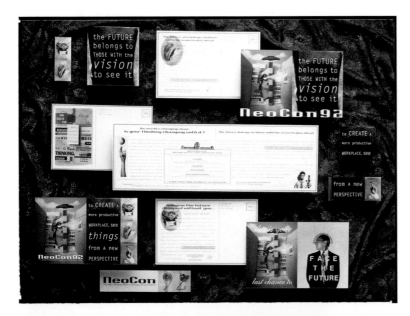

CLIENT:
Merchandise Mart
DESIGN FIRM:
Segura Inc.
Chicago, Illinois
ART DIRECTOR:
Carlos Segura
DESIGNER:
Carlos Segura
PHOTOGRAPHER:
Geof Kern

This mailing series promotes an annual conference on workplace design. A collage photograph becomes sort of a visual logo for the event.

CLIENT:
David Carter Design Associates
DESIGN FIRM:
David Carter Design Associates
Dallas, Texas
ART DIRECTOR:
Lori B. Wilson
DESIGNER:
Lori B. Wilson

"We Think the World of Christmas" is the theme of this annual holiday promotion. Its text describes holiday customs from around the globe.

CLIENT:
Gilbert Paper
DESIGN FIRM:
THIRST
Chicago, Illinois
ART DIRECTOR:
Rick Valicenti

Patterned after the Surrealists' 1920s game of artistic chance, this piece passes artwork from one participant to the next. All three pieces invited designers from around the globe. The first shared designs via the electronic disc; the second instructed all computers to be switched off; and the third included students and took "the future" as its theme.

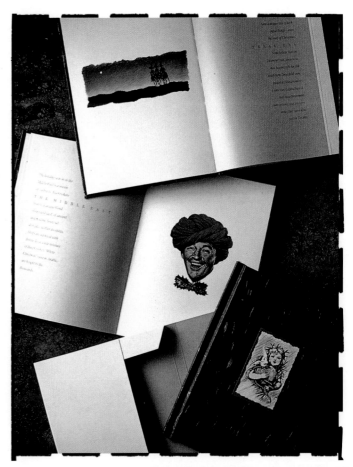

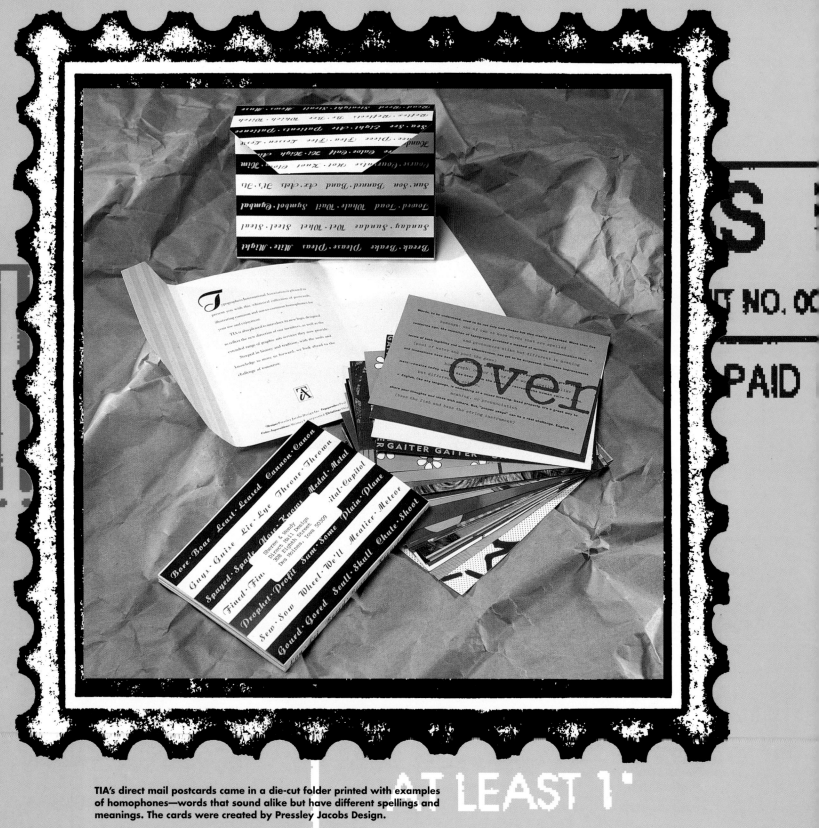

TIA's direct mail postcards came in a die-cut folder printed with examples of homophones—words that sound alike but have different spellings and meanings. The cards were created by Pressley Jacobs Design.

Direct Mail
Postcards

Wendy Pressley-Jacobs designs direct mail with a mission: Her projects must have a big idea. The designer firmly believes a direct mail piece can't just look good, it has to have a concept and solve a problem.

When Typographers International Association (TIA), an organization that promotes the field of typography, asked Pressley Jacobs Design to come up with a new logo for the group—and a concept that would introduce and promote their new identity—the firm's big idea came in a little package. They designed a set of 26 small postcards to illustrate common English words that sound alike, but have different meanings and spellings. Clever designs mix "aunt" and "ant," "flower" and "flour," "yoke" and "yolk." This creative approach not only gets attention, it gets recipients to keep the cards as a handy reference.

TIA originally requested a poster for the direct mail campaign. But companies are often sent posters—which get looked at once, then thrown away. Pressley-Jacobs' firm came up with the idea of postcards. They're useful, and because of their size, they're easy to put up on a bulletin board or wall.

The typography industry is changing rapidly. Computer-aided design has become common, and typographers have had to expand their services to attract clients. In putting together a direct mail campaign, TIA wanted to promote their new logo and to remind businesses that being a good wordsmith is part of the professional typographer's job.

TIA member companies bought the postcards through the association. Most added their own logo to

TIPS FOR EFFECTIVE DIRECT MAIL DESIGN

1. **Brainstorm. Be original.**

2. **Think like the audience. Get inside their head; what are their habits? What drives them crazy?**

3. **Have a big idea.**

the cards, then sent them out to clients. The end users—art directors and designers who use typographers—could hang the postcard up or use it for correspondence. The design's flexibility added to its success: typographers could send clients the whole set of cards at once, or mail them out one at a time—thus transforming a single package into a whole direct mail promotional campaign. This strategy worked with a lot of different typographers' promotional budgets.

People loved the campaign. At TIA, the postcards quickly sold out. The set's variety of design had something for most personalities—everyone had their own favorite card.

The theme itself came from a brainstorming session between Pressley-Jacobs and project designer Mark Myers; they began joking about designers and art directors' legendary misspellings. Thinking it would be fun to play on this stereotype, Myers came up with 26 pairs of words—one for each letter of the alphabet—that sound alike but are spelled differently.

A small production budget meant all design had to be done in-house. With no money for outside illustration or photography, staff had to be resourceful. The designers divided the cards evenly, then chose the

words they wanted to depict. Some convinced friends to contribute illustrations or photography for their postcards. The creative guideline was simple: only one word in the pair could be spelled out—the second word had to be depicted by illustration alone.

The hilarious results let the design firm show off typography and play with different fonts. On individual cards, font styles work together with illustrations to create the message. Thus, the typewritten word "aunt" swarms over one card, mimicking ants on an ant hill. A hare sits placidly behind flowery script that spells out "hair." Two ewes demonstrate the word "use." And a medieval-style font em-blazons "knight" across the night sky.

Phrases by copywriter Paul McComas—using both words in a pair correctly—add to the postcard's functional appeal. The "aunt" card reads: "You might ask an aunt or an uncle to join you on a picnic; an ant, however, needs no invitation." The major typeface used is also noted, so the recipients keep the cards as a reference.

This design delivers—the concept hits home, while copy and the design are woven together to communicate the message. It's clever, and it makes people think. ∎

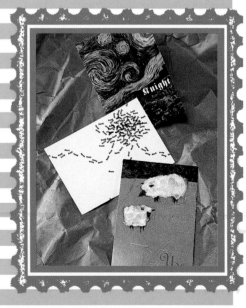

Knight guarding night, aunt mimics ant, and useful ewes were three of the attention-grabbing designs on the TIA postcards.

The mailing contained 26 postcards. TIA members could send a client the whole set, or one card at a time to lengthen the life of the campaign.

CLIENT:
Typographers International Association
DESIGN FIRM:
Pressley Jacobs Design
Chicago, Illinois
ART DIRECTOR:
Mark Myers
DESIGNER:
Mark Myers, Barbara Bruch, William Lee Johnson, Craig Ward, Kimberly Kryszak, Amy Warner McCarter, Susan McQuiddy
COPYWRITER:
Paul McComas

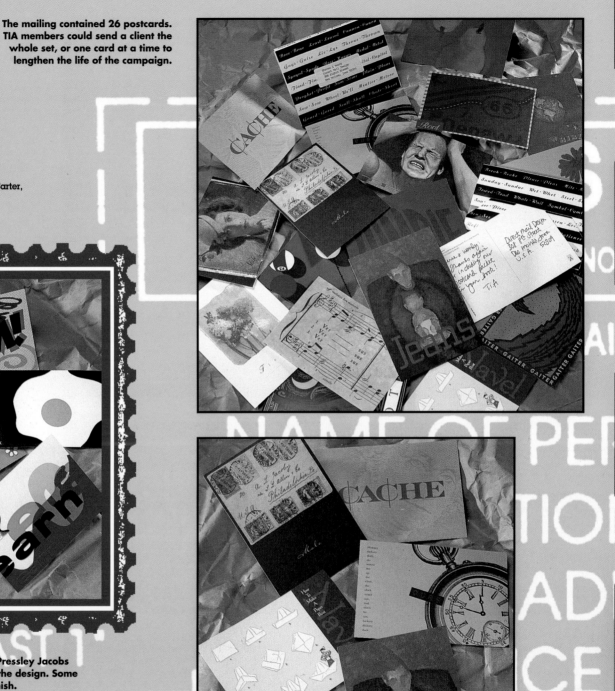

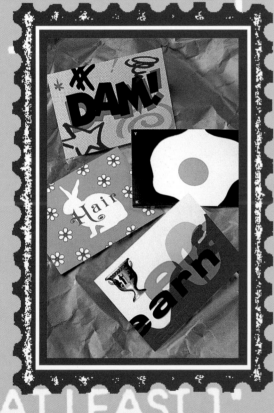

To hold down production costs, Pressley Jacobs used only three paper stocks in the design. Some of the postcards had a glossy finish.

Uncoated paper was also used to add variety and texture.

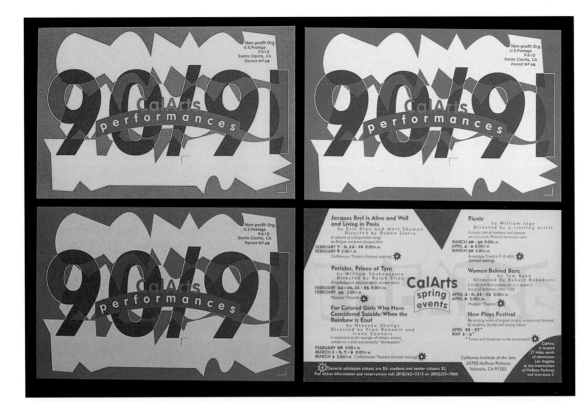

CLIENT:
Cal Arts
DESIGN FIRM:
Cal Arts Office of Public Affairs
Venice, California
ART DIRECTOR:
Caryn Aono
DESIGNER:
Robin Cottle

The same two inks respond very differently depending on the color of paper stock used, as these postcards demonstrate.

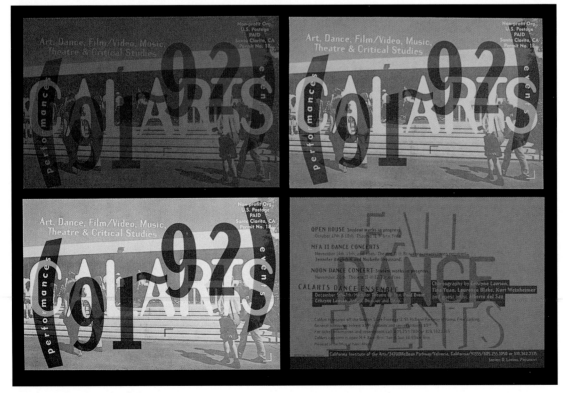

CLIENT:
Cal Arts
DESIGN FIRM:
Cal Arts Office of Public Affairs
Venice, California
ART DIRECTOR:
Caryn Aono
DESIGNER:
Robin Cottle
PHOTOGRAPHER:
Steve Gunther

Neon-colored paper adds vibrancy to postcards designed for a university. The inks react to the paper colors in different ways.

CLIENT:
**Stewart Monderer
Design, Inc.**
DESIGN FIRM:
**Stewart Monderer
Design, Inc.
Boston, Massachusetts**
ART DIRECTOR:
Stewart Monderer
DESIGNER:
Robert Davison
ILLUSTRATOR:
Richard Goldberg

**These self-promotional
postcards were mailed
every two weeks as
a series. Punched-out
numbers create a visu-
al focal point on one
side and serve as a
sequential numbering
device on the other.**

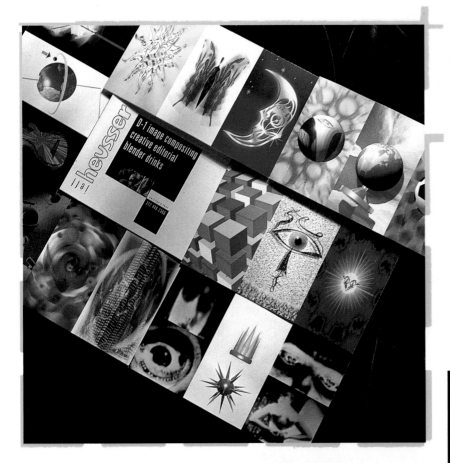

CLIENT:
Editel/Chicago
DESIGN FIRM:
THIRST
Chicago, Illinois
ART DIRECTOR:
Rick Valicenti
DESIGNER:
Rick Valicenti
ILLUSTRATOR:
THIRST

Each editor was given the opportunity to individualize their own postcard by suggesting three "descriptive things" to computer manipulate for a "triptcyh-like" postcard.

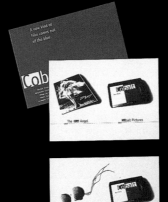

CLIENT:
Cobalt Pictures
DESIGN FIRM:
Liska and Associates, Inc.
Chicago, Illinois
ART DIRECTOR:
Steven Liska
DESIGNER:
Sarah Faust
PHOTOGRAPHER:
Ken Reid

Some design ideas just come out of the blue . . . like this mail series for Cobalt Pictures. Aptly using wordplay and the right color ink brought the concept full-circle.

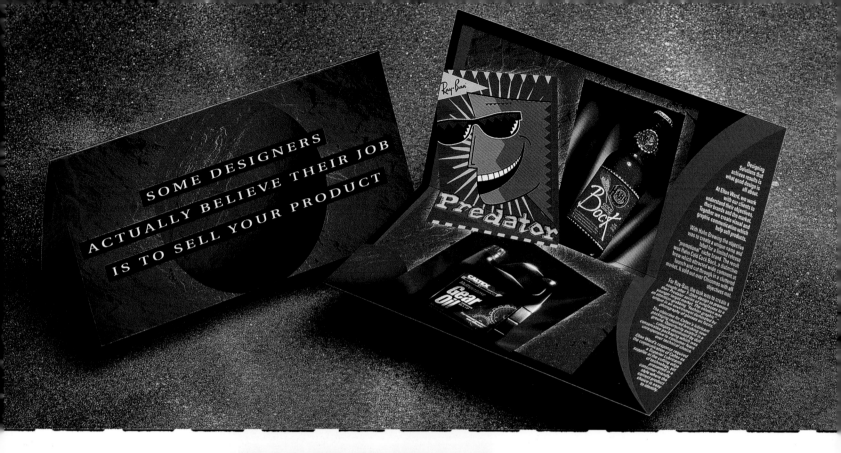

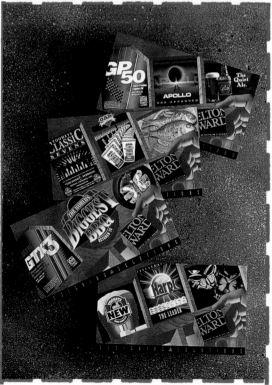

CLIENT:
Elton Ward Design
DESIGN FIRM:
Elton Ward Design
Australia
ART DIRECTOR:
Steve Coleman
DESIGNER:
Andrew Schipp
ILLUSTRATOR:
Andrew Schipp

Copy in this fold-over postcard focuses on one firm's view of a successful client relationship. Examples are given in a case-study approach.

CLIENT:
Elton Ward Design
DESIGN FIRM:
Elton Ward Design
Australia
ART DIRECTOR:
Steve Coleman, Chris DeLisen
DESIGNER:
Chris DeLisen, Andrew Schipp

A direct mail series for a design firm gives recipients a sample of the group's work. The woodgrain background on each card ties the program together.

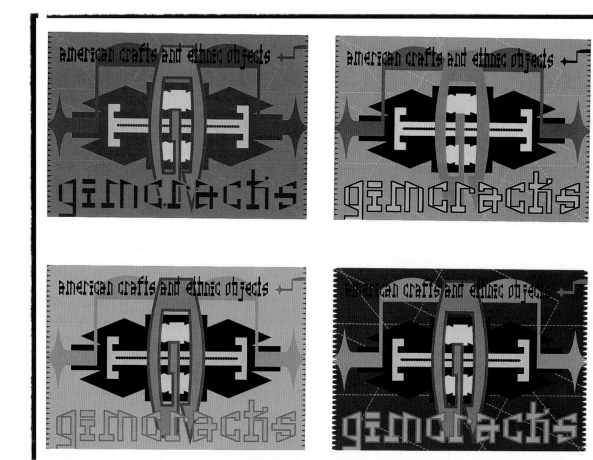

CLIENT:
Gimcracks
DESIGN FIRM:
**Segura Inc.
Chicago, Illinois**
ART DIRECTOR:
Carlos Segura
DESIGNER:
Carlos Segura

Three dimensional images were scanned as art to create this four-card campaign promoting American crafts and ethnic objects.

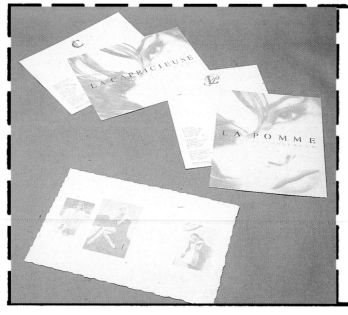

CLIENT:
La Capricieuse & La Pomme
DESIGN FIRM:
**Blue Sky Design
Miami, Florida**
ART DIRECTOR:
Maria Dominguez
DESIGNER:
Maria Dominguez

La Capricieuse (Coconut Grove, Florida) and LaPomme (Aruba) are fashion boutiques catering to an upscale clientele. Gold and silver foils and a natural speckled paper were used to bring the two stores' neoclassical interior designs to customers.

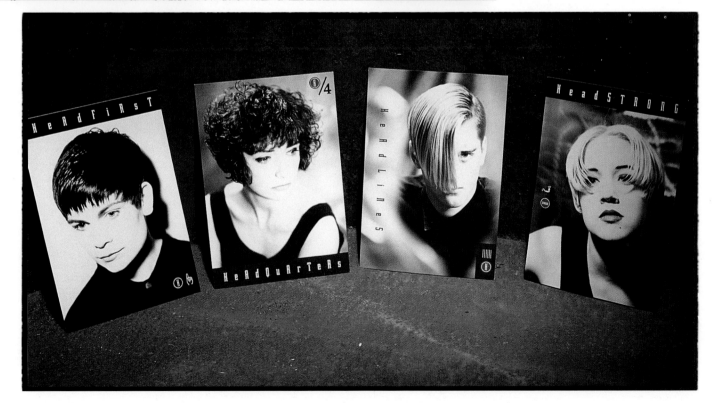

CLIENT:
Segura Inc.
DESIGN FIRM:
Segura Inc.
Chicago, Illinois
ALL DESIGN BY:
Carlos Segura

Individual postcards are sent in a folder to create a "logo kit." The piece was developed by a design firm to demonstrate their corporate identity design capabilities.

CLIENT:
LaMop Hair Studio
DESIGN FIRM:
Planet Design Company
Madison, Wisconsin
ART DIRECTOR:
Kevin Wade, Dana Lytle
DESIGNER:
Kevin Wade
PHOTOGRAPHER:
John Urban

Headfirst, Headstrong, Headquarters, Headlines: A series of cards designed for "casual use" in generating new customers and re-establishing past patron relations. Duotone photographs add appeal.

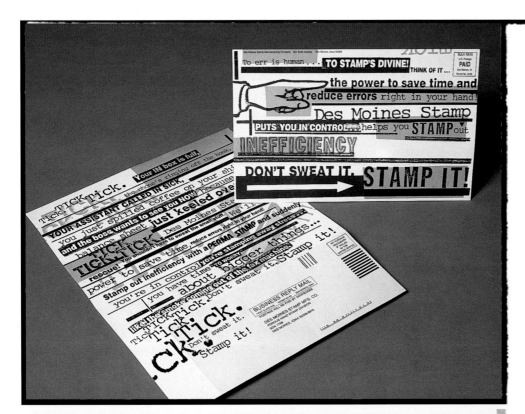

CLIENT:
Des Moines Stamp Manufacturing
DESIGN FIRM:
Sayles Graphic Design
Des Moines, Iowa
ALL DESIGN BY:
John Sayles

In the slick and glossy mail market-place, this rough-edged postcard mailer makes a statement.

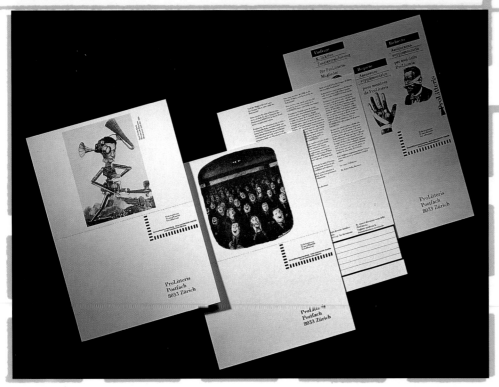

CLIENT:
ProLitteris
DESIGN FIRM:
Gottschalk & Ash International
Zürich, Switzerland
DESIGNER:
Fritz Gottschalk, Andreas Gossweiler
ILLUSTRATOR:
Chas Addams, Otto Umbehr

This simple and straightforward series of direct mail pieces is recruiting more ProLitteris members. Target audience: Writers, journalists, authors, artists, and graphic designers.

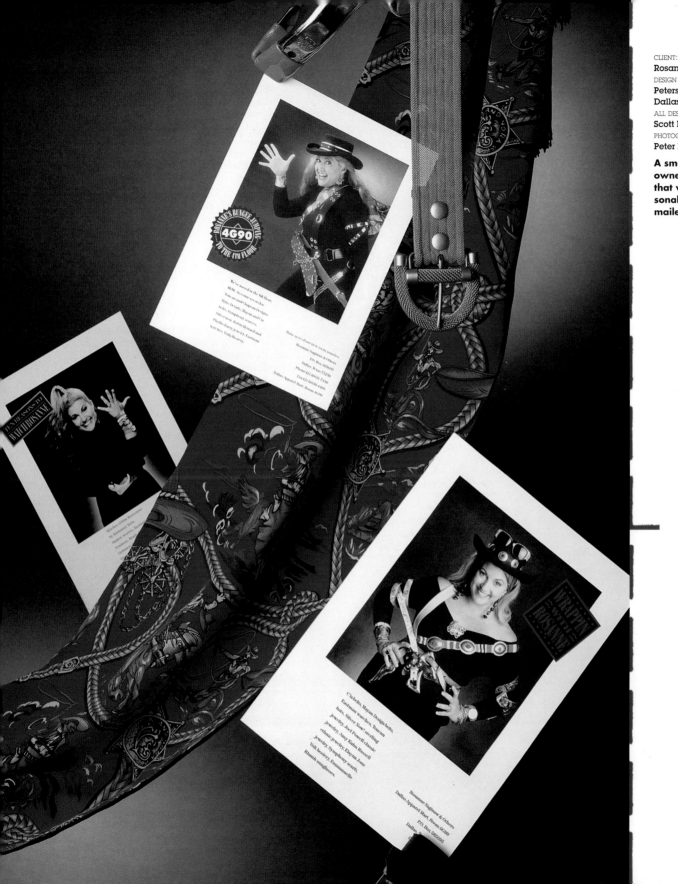

CLIENT:
Rosanne Saginaw
DESIGN FIRM:
Peterson & Company
Dallas, Texas
ALL DESIGN BY:
Scott Ray
PHOTOGRAPHER:
Peter Lacker

A small accessories business owner needed a promotion that would reflect her personality. These cards were mailed to distributors.

CLIENT:
Tony Stone Images
DESIGN FIRM:
Concrete
Chicago, Illinois
DESIGNER:
Jilly Simons, Cindy Chang

Simple copy and graphics make a statement in this postcard series announcing the relocation of a photographer.

CLIENT:
Stoltze Design
DESIGN FIRM:
Stoltze Design
Boston, Massachusetts
ART DIRECTOR:
Clifford Stoltze
DESIGNER:
Clifford Stoltze, Peter Farrell, Rebecca Fagan

These cards were a holiday self-promotion using three words (Love, Peace, and Understanding) with their dictionary definitions and some interesting typography. The three wish cards were designed to be reused by the recipients as postcards.

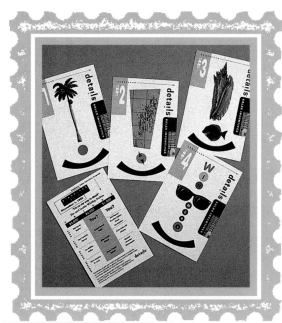

CLIENT:
Details
DESIGN FIRM:
Worksight
New York, New York
ALL DESIGN BY:
Scott W. Santoro

The company trademark— an exclamation point—was used in conjunction with Hawaiian imagery for this sales incentive series. Updated competition standings were included on the back of each card.

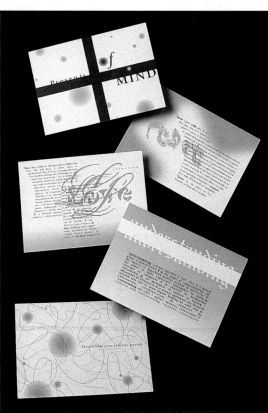

CLIENT:
LTV
DESIGN FIRM:
Peterson & Company
Dallas, Texas
ALL DESIGN BY:
Scott Ray

These postcards were mailed directly to the homes of company employees to encourage family members to enroll in a company-provided assistance program.

CLIENT:
Janet Botaish Group
DESIGN FIRM:
Robin Cottle Design
Venice, California
ALL DESIGN BY:
Robin Cottle

By using different paper stocks, these postcards give the illusion of being two-color mailers, yet only one ink was used for each.

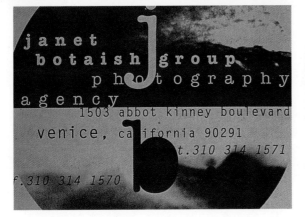

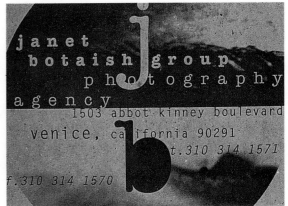

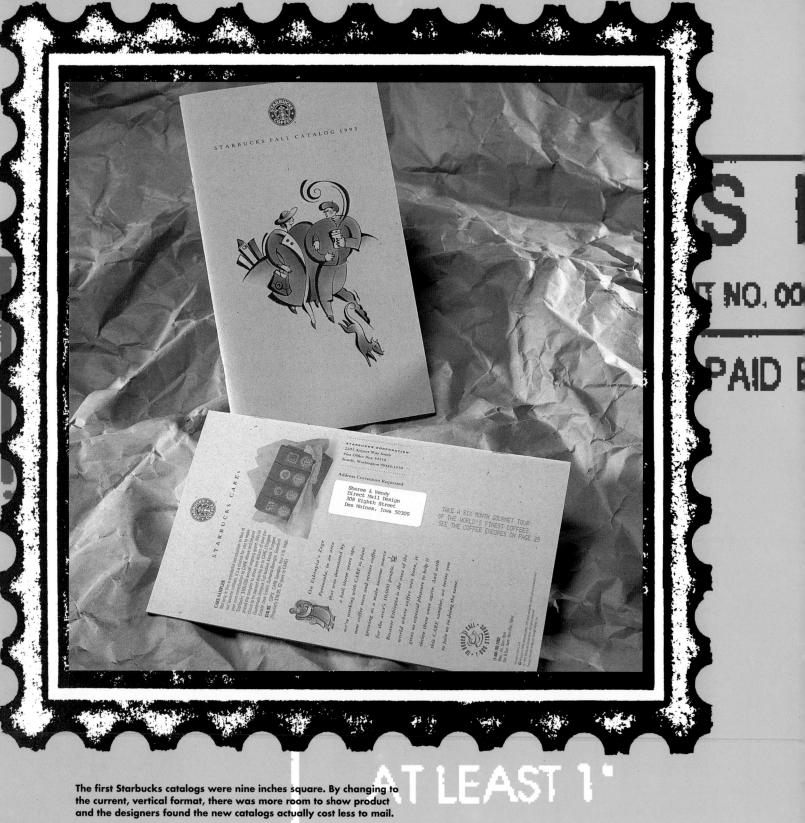

The first Starbucks catalogs were nine inches square. By changing to the current, vertical format, there was more room to show product and the designers found the new catalogs actually cost less to mail.

Direct Mail
Catalogs

Most mail-order catalogs do one thing . . . sell products. They generally don't work hard at conveying a company's identity. In the dollar-driven business world, it takes a courageous company to invest in a catalog that projects image as well as it sells inventory.

One catalog that gives mail-order customers a real feeling for the business it represents is the Starbucks Coffee catalog. A Seattle-based chain of nation-wide retail coffee stores, Starbucks offers the reader more than just a list of products and prices. Hornall Anderson Design Works designed the catalogs to duplicate the experience of stepping into a Starbucks shop. Soft illustrations in warm colors, together with "natural" paper and light and down-to-earth copy build Starbucks' image as the friendly headquarters of peo-ple who know coffee. Even the catalog's photography was shot to resemble sun shining through a kitchen window onto the product.

The catalogs have worked well for Starbucks. People enjoy reading them. They have become keepsakes and have inspired many Starbucks imitators. Best of all, sales have increased. The catalogs have helped position the coffee company as an industry leader.

Starbucks' ground-breaking cata-log campaign began in 1991, when the company approached Hornall Anderson Design Works to redesign their coffee bags. Starbucks wanted its packaging and retail stores to capitalize on the image of the company's coffee—rich and premium.

Pleased with the new packaging, Starbucks hired Hornall Anderson to create the company's premier

TIPS FOR EFFECTIVE DIRECT MAIL DESIGN

1. **Good Timing.**
 Many things make a catalog's success: Great design won't sell poor products. Make sure the client's prices, products, and mailing list make sense before you begin.

2. **No Guessing.**
 Catalog photography is very important, customers need to see the product clearly, or they won't buy it.

3. **Daily Variety.**
 In mail order, too much continuity works against you. Keep campaigns fresh; catalog covers should be different enough in color and image so customers realize it's a new catalog.

4. Keep in mind that catalogs need a flexible format because products constantly change.

annual report. The report's warm, flowing illustrations of people enjoying Starbucks coffee really struck a chord with CEO Howard Schultz. A new design for the coffee company's catalogs came next. Starbucks had a clear idea of what it wanted: to sell coffee by mail-order and to position themselves as experts in the coffee business.

The first catalog highlighted "coffees of the world" and educated customers about how and where coffee was grown. Later issues have become somewhat more photographic, as Starbucks' offerings expand from coffee to accessories such as presses and mugs.

Starbucks' catalogs are an unusual size and have outside pages printed on Kraft paper, which immediately sets them apart from the more common, glossy-paper mailings. Copy is kept friendly and conversational. All members of the catalog design team attended Starbucks' "Coffee School" to learn about the company. Even the sales text is personal and human: "For

those who are curious, but don't want to commit to just one (what if you missed something?), we've gathered together four half-pounds of our exclusive blends."

Hornall Anderson feels the catalogs have been successful because they break the rules. From size and paper, to photography, illustration, and the playful tone of the copy, Starbucks' catalogs push the envelope.

Interestingly, the Starbucks catalogs also succeed in an industry whose standards measure the number of square inches dedicated to a specific product against the number of phone calls for orders. As a rule, catalogs are modified constantly to sell more and more product. Taking up space to project an image at the expense of an item is a risk; Starbucks' catalogs have broken new ground with their balance of storytelling and product selling. As it turns out, using great design to build an image is a good investment. And for Starbucks Coffee, it's money in the bank. ■

CLIENT:
Starbucks Coffee Company
DESIGN FIRM:
**Hornall Anderson Design Works, Inc.
Seattle, Washington**
CATALOG TEAM:
Jack Anderson, Julie Tanagi-Lock, Julie Keenan, Leslie MacInnes, Ellen Elfering
COPYWRITER:
Pamela Mason Davey
ILLUSTRATOR:
Julia LaPine
PHOTOGRAPHER:
Darrell Peterson

Warm, rich illustrations on Kraft paper have become a trademark of the Starbucks catalog.

The catalog's style and illustration are consistent, but each edition's cover is different enough so the recipient recognizes they're seeing something new.

It's the details that make these catalogs winners. For example, Starbucks' products were photographed using special lighting to give the effect of morning sun shining through a kitchen window.

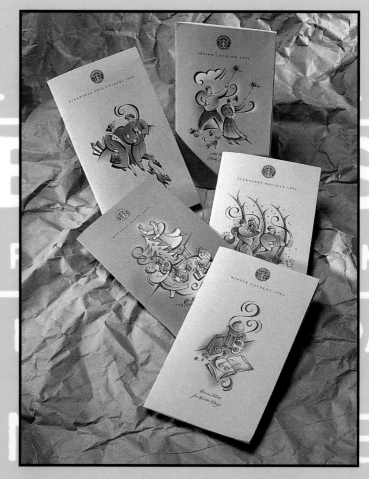

There are five different Starbucks catalogs designed each year—one for every season and one for holiday time. The illustrations and photography depict the catalog's seasonal theme.

CLIENT:
Tristan & Iseut
DESIGN FIRM:
PAPRIKA
Montréal Québec Canada
ALL DESIGN BY:
Louis Gagnon
PHOTOGRAPHER:
Pierre Choiniére

Using a fashion magazine format, this North American boutique publishes two such catalogs per year.

CLIENT:
Jane Jenni
DESIGN FIRM:
Olson Johnson Design Company
Minneapolis, Minnesota
DESIGNER:
Haley Johnson
PHOTOGRAPHER:
George Peer

An art photography catalog features sample photographs that slip into die-cut slots; accompanying labels hand-glued to the pages list the artist's name and a reference number that expedites phone orders.

CLIENT:
Converse
DESIGN FIRM:
**Jager Di Paola Kemp Design
Burlington, Vermont**
ART DIRECTOR:
Steve Farrar, Michael Jager
DESIGNER:
Steve Farrar, Dan Sharp
PHOTOGRAPHER:
**Aaron Warkov, Peter Rice,
Michael Jager**

A mix of product-in-use location images and photographs shot in extreme close-up produces a compelling effect. Vertically-printed copy is an added twist.

CLIENT:
Converse
DESIGN FIRM:
**Jager Di Paola Kemp Design
Burlington, Vermont**
ART DIRECTOR:
Steve Farrar, Michael Jager
DESIGNER:
Steve Farrar, Kirk James, Steve Redmond
PHOTOGRAPHER:
Aaron Warkov

The "On the Road" theme appeals to the lifestyles and fantasies of young consumers—who have embraced styles from punk to preppy. A series of perforated postcards adds to the theme and engages reader involvement.

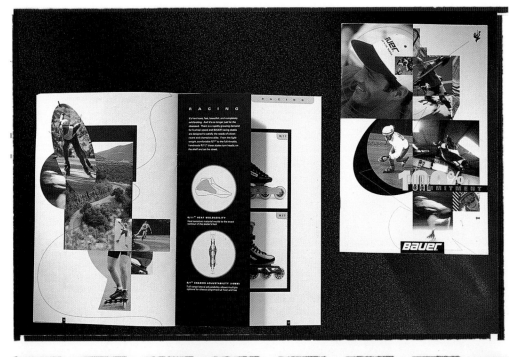

CLIENT:
Canstar
DESIGN FIRM:
Jager Di Paola Kemp Design
Burlington, Vermont
ART DIRECTOR:
Giovanna Jager, Michael Jager
DESIGNER:
Giovanna Jager
PHOTOGRAPHER:
Geoff Fosbrook, Victoria Pearson, Stuart Watson

A dealer workbook conveys the energy of the sport. The short sheets provide technical features and benefits, and the chart in the back summarizes the line. The smaller format gives the catalog a tech-manual feeling.

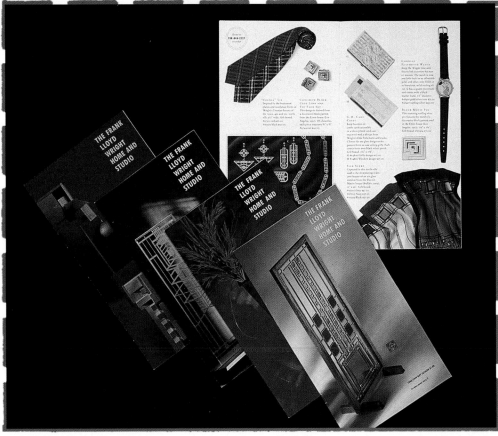

CLIENT:
Frank Lloyd Wright Home and Studio
DESIGN FIRM:
Lipman Hearne
Chicago, Illinois
ALL DESIGN BY:
Frank Anello, Amy Srubas

Featuring appealing and clean design, these annual gift catalogs target "design sensitive" shoppers, such as design professionals and architects.

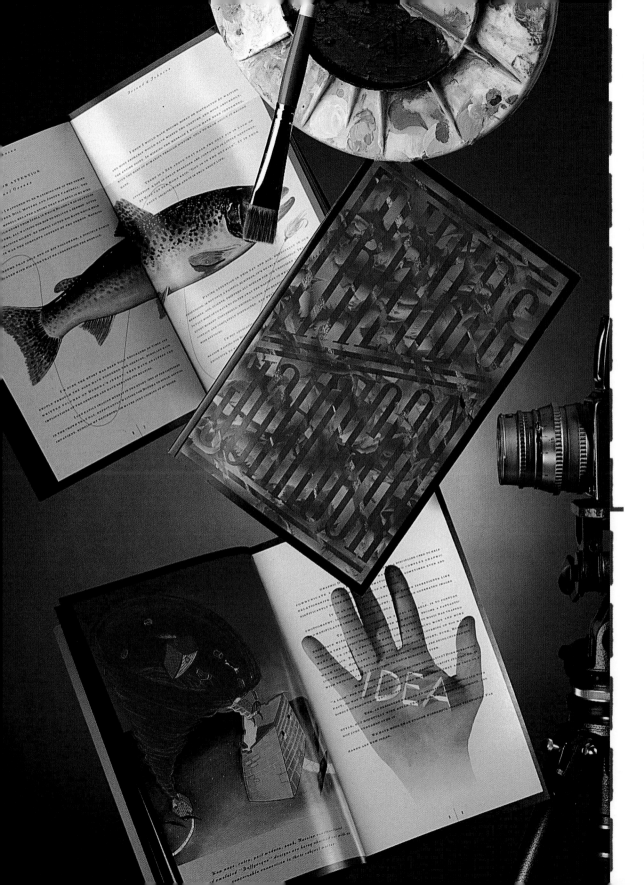

CLIENT:
Friend & Johnson
DESIGN FIRM:
**Peterson & Company
Dallas, Texas**
ART DIRECTOR:
Bryan Peterson
DESIGNER:
**Bryan Peterson,
Scott Paramski**

This promotion for a photographer/illustrator representation firm carries a simple business reply card for reader response and an invitation to see a complete portfolio.

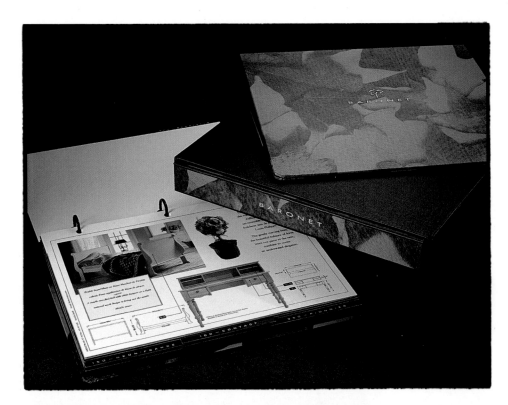

CLIENT:
Baronet
DESIGN FIRM:
PAPRIKA
Montreal, Québec Canada
ALL DESIGN BY:
Louis Gagnon
PHOTOGRAPHER:
Michel Touchette

Circulated in the United States, Canada, and Europe, this furniture catalog was developed for retail stores and distributors.

CLIENT:
Von Wedell & Associates/Kartel
DESIGN FIRM:
THIRST
Chicago, Illinois
ALL DESIGN BY:
Rick Valicenti
ILLUSTRATOR:
Tony Klassen
PHOTOGRAPHER:
Tom Vack

Computer illustrations depict this Italian company's spring furniture line. The catalog premiered at the Italian Furniture Fair, Salone, in Milano.

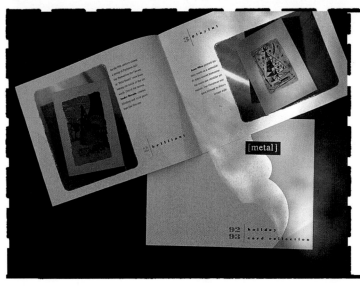

CLIENT:
[metal] Studio
DESIGN FIRM:
Peat Jariya Design
Houston, Texas
ALL DESIGN BY:
Peat Jariya, Scott Head

This Christmas card catalog poetically describes each card and explains the designer/illustrator's inspiration for each design.

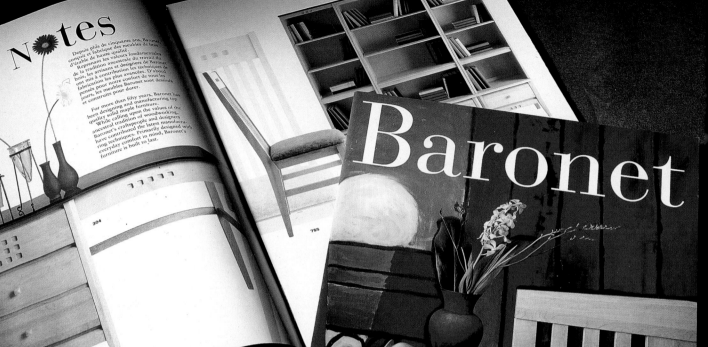

CLIENT:
Baronet
DESIGN FIRM:
PAPRIKA
Montréal, Québec Canada
ALL DESIGN BY:
Louis Gagnon
PHOTOGRAPHER:
Michel Touchette, François Brunelle

Vivid photography enhances products in this furniture catalog. It was circulated to consumers as well as to stores and distributors.

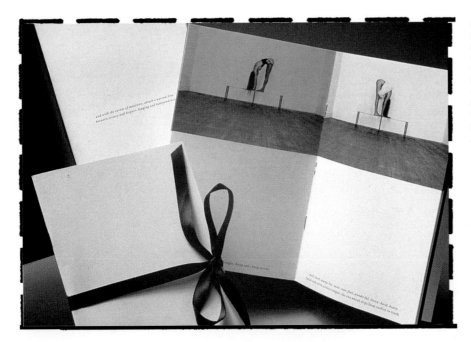

CLIENT:
Sarah Schwartz
DESIGN FIRM:
Concrete
Chicago, Illinois
DESIGNER:
Jilly Simons, Susan Carlson,
Sarah Schwartz
PHOTOGRAPHER:
Sara Schwartz

Only 800 copies of this limited edition lingerie catalog were printed, and each was sold for 12 dollars. The catalog's model is also the photographer.

CLIENT:
Gemini G.E.L.
DESIGN FIRM:
COY, Los Angeles,
Culver City, California
ART DIRECTOR:
John Coy
DESIGNER:
John Coy, Laurie Handler, Janine Vigus
ILLUSTRATOR:
Claes Oldenburg
PHOTOGRAPHER:
Sidney B. Felsen,
Douglas M. Parker

The format of this catalog is easily identifiable and extends the metaphor of the artist's work in a personal presentation of his most recent projects.

CLIENT:
Art Institute of Boston
DESIGN FIRM:
Stoltze Design
Boston, Massachusetts
ALL DESIGN BY:
Clifford Stoltze

A flexible grid and metallic PMS colors on uncoated-paper give this college catalog the look of a magazine.

CLIENT:
Birkenstock
DESIGN FIRM:
Cahan & Associates
 San Francisco, California
ART DIRECTOR:
Bill Cahan
DESIGNER:
David Gilmour
PHOTOGRAPHER:
David Peterson

This mailing was designed to create a new image for Birkenstock sandals; changing the product's position from an "orthopedic" niche to a fashion/comfort market share.

CLIENT:
The Container Store
DESIGN FIRM:
Sibley/Peteet Design, Inc
Dallas, Texas
ART DIRECTOR:
Rex Peteet
DESIGNER:
Rex Peteet, David Beck, Donna Aldridge
PHOTOGRAPHER:
Tom Ryan

Going back to school is a popular time to organize. The design of this back-to-school catalog is clean and bold to attract freshman shopping for dorm room supplies.

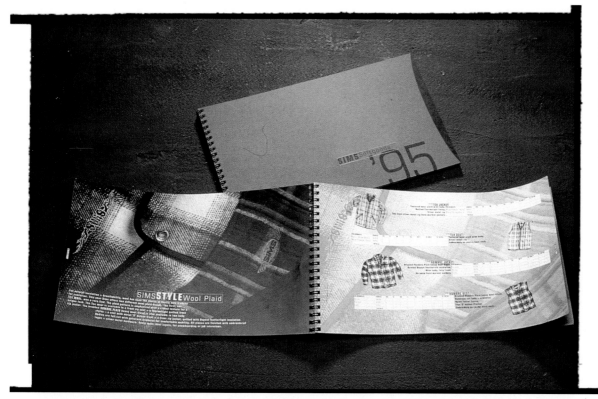

CLIENT:
Sims Snowboard Corporation
DESIGN FIRM:
**HerRainco Design Associates Inc.
Vancouver, BC Canada**
ALL DESIGN BY:
Matt Warburton
PHOTOGRAPHER:
Robert Earnst

The products in this catalog are emphasized with photographic title-divider pages, each capturing the personality of a particular model.

CLIENT:
William Reuter Design
DESIGN FIRM:
**William Reuter Design
San Francisco, California**
ART DIRECTOR:
William Reuter
DESIGNER:
**William Reuter, Jose Bila,
Rodriquez, Michael Bain**

A small, 11"x4" catalog of projects acts as a mini-portfolio for a design firm. Because the mailers are sent out in small batches, the firm's staff hand-assembles the books as needed, using screws and rubber washers.

Kleine Gesten, große Wirkung.
Geschenke für Ihre Kunden.

Der Vereinsbank
Geschenkkatalog 1994

Vereinsbank

BAYERISCHE
VEREINSBANK AG

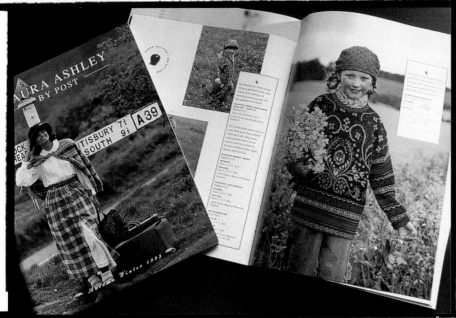

CLIENT:
Vereinsbank
DESIGN FIRM:
Gottschalk + Ash International
Zürich, Switzerland
DESIGNER:
Thomas Strub, Wolfgang Meder
PHOTOGRAPHER:
Heiner Bayer

**A catalog of gift ideas for bank customers is sent to
branch managers.**

CLIENT:
Laura Ashley, Inc.
DESIGN FIRM:
Clifford Selbert Design
Cambridge, Massachusetts
ALL DESIGN BY:
Nancy Brown, Julia Daggett

**Appropriate design details and evocative copy enhance
the Laura Ashley image. The development of a design
grid makes the overall production process easier. The
result? A 30 percent increase in catalog sales.**

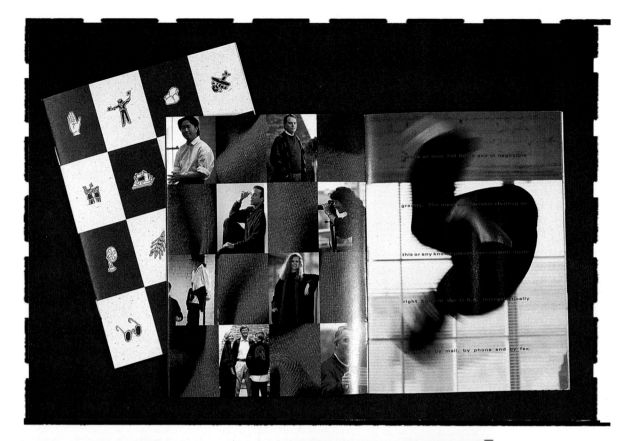

CLIENT:
Cronan Artefact
DESIGN FIRM:
Cronan Design
San Francisco, California
ALL DESIGN BY
Michael Cronan
PHOTOGRAPHER:
Terry Lorant

A graphic designer in his own right, the owner of this mail-order organization uses friends and members of the design community as catalog models.

CLIENT:
Burton
DESIGN FIRM:
Jager Di Paola Kemp Design
Burlington, Vermont
ART DIRECTOR:
David Covell, Michael Jager
DESIGNER:
David Covell, Adam Levite

The Advanced Snowboard Science theme ties into the target market's school days in a humorous way, yet carries a serious message that this company invests in continual R&D to build the best snowboards and equipment in the industry.

CLIENT:
eyeOTA
DESIGN FIRM:
eyeOTA Inhouse Studio
Culver City, California
ART DIRECTOR:
David Kilvert
DESIGNER:
Krista Kilvert, David Kilvert
PHOTOGRAPHER:
Amedeo

In this catalog, the graceful, elegant lines of the eyeOTA product are represented by the movement and expressions of the human body. Models were chosen for their training in yoga and dance.

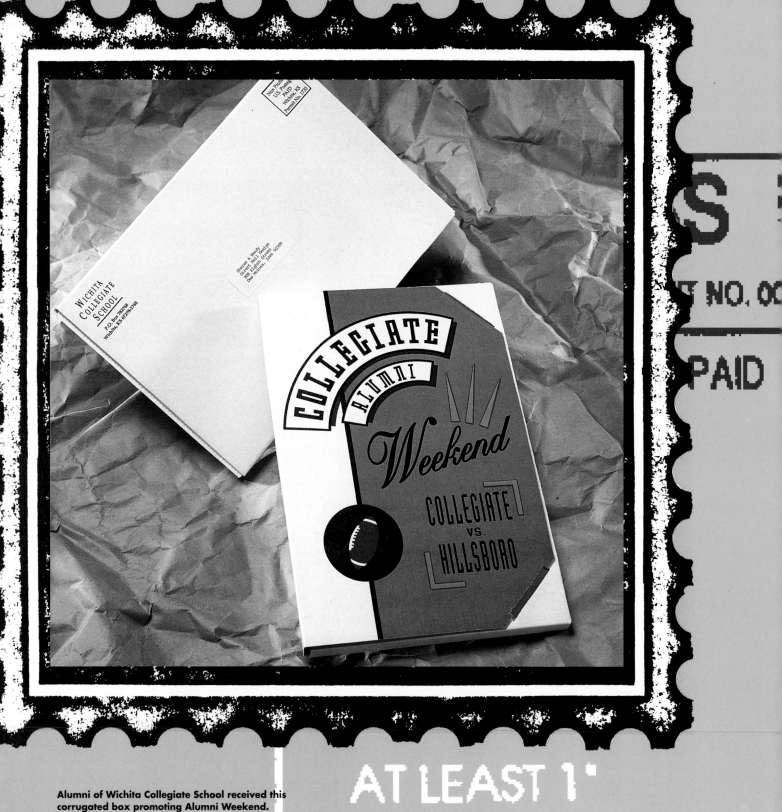

Alumni of Wichita Collegiate School received this corrugated box promoting Alumni Weekend.

Nonprofit/
Association
Mailings

Making the sender's message jump out is one of the secrets of effective direct mail design. Love Packaging Group created a mailing for Wichita Collegiate School that literally did just that.

Direct mail design for nonprofit organizations has its own set of challenges. Unlike a catalog or business-to-business mailing, a tangible product or service isn't always what's being sold. Nonprofit organizations commonly use direct mail to raise funds or recruit volunteers. For designers, creating nonprofit mailings often means working with a minimal production budget. Yet, because these mailings tend to appeal to the emotions of the recipient, designers can use their creativity freely and use those great ideas that don't often lend themselves to more corporate clients.

For past reunions the school had used a simple, photocopied invitation to save money. The year Love Packaging designed the mailer, company Vice President Randy Love donated the invitations to the high school. Love is an alumnus of Collegiate, and the school was founded by his family. Although the piece was a donation, Love didn't limit the production budget...a rare thing for a nonprofit project. His decision was a good one: Love's design team created a direct mail piece that not only increased reunion attendance, it also won awards and publicity for the company.

Collegiate alumni received a 12"x8" corrugated folder overpack printed with retro-style graphics. Inside, there's a corrugated "football field" folded in half like a book. When the recipient opens the "field," a corrugated football hidden inside pops up and flies out of the mailing. The three-dimensional football has been reported to have jumped nearly 12 feet in some cases!

Copy on the "field" contains information about the reunion, including dates, ticket information, and a schedule of events.

School officials were thrilled with the response to the mailing. The invitation was well received by alumni,

TIPS FOR EFFECTIVE DIRECT MAIL DESIGN

1. **Study Surfaces.**
 Three-dimensional design on multiple surfaces expands your creativity.

2. **Cost Check.**
 Take a rough sketch of the mailing to the post office to get an idea of mailability and price.

3. **Supply Search.**
 Source for any supplies, such as hardware and fasteners, well in advance of your deadline.

4. **Use Specialists.**
 The Collegiate piece worked because it was a team effort combining expertise in structural and graphic design.

giving the event the added benefit of word-of-mouth endorsement. When Collegiate held its annual telephone campaign, the popping football was a common topic of conversation.

The creative inspiration for the project was a diamond-shaped magazine pop-out that Love's marketing director had seen several years ago. When the company was asked to design the invitation for Collegiate, the pop-out idea seemed like a natural because the reunion's premier event was the homecoming football game.

Design staff experimented with several designs to get the football to work, eventually settling on a minimalist style with eight sides. Since the company was not using computer-aided design for structures at the time, they cut-and-pasted together a crude working model—then adjusted it until it worked. For a more finished look, the edges on the football were made smooth by bending the corrugated board under at the seams. The real trick was to keep the geometric form looking like a football and still have it pop up. Corrugated material does not naturally have "memory" to pop up by itself, so it needs some kind of spring device. Finding the right rubber band took several tries—some sizes lost their elasticity after they'd been stretched inside the football too long.

After the mechanics of the mailing were smoothed out, Love's designers went to work creating the graphics. The graphics have the critical job of leading the recipient through the mailing. Using a bold graphic style, the design's objective was to inspire recipients' nostalgia for the school and to rekindle a bit of homecoming game excitement. The graphic format needed to accommodate flexographic printing on corrugated, so the graphics have big, bold lines to allow for the trapping associated with this printing technique. Printing on corrugated can be quite a challenge. Things have a tendency to shift on the press, so graphics have to overlap from 1/8 to 1/4 of an inch. Because a big gripper edge is needed, graphics can't be too close to the edges or the printing might run off.

The project's art director liked the opportunity to create something artistic on corrugated. His job involves the production of a lot of boxes that end up in warehouses. This project gave him a chance to design something functional, yet exciting.

What makes this piece so successful is the added dimension of unexpected motion. The football pops out all by itself; the recipient doesn't have to do anything more than open the mailer. This is a key that makes the Collegiate invitation really capture the excitement of the event. People who received it thought, "This is a quality piece...the event must be quality, too. I really want to be there!" ∎

CLIENT:
Wichita Collegiate School
DESIGN FIRM:
Love Packaging Group
Wichita, Kansas
ALL DESIGN BY:
Brian Miller

Inside the mailer, a "football field" printed on corrugated slips out of an inner pocket.

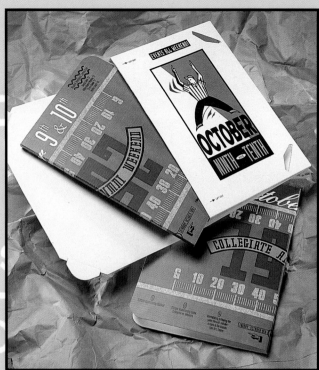

The Collegiate Alumni Weekend mailing was a successful combination of structural and graphic design.

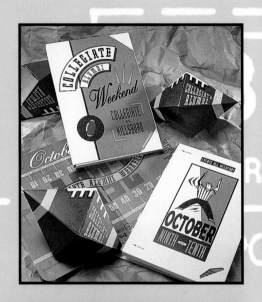

When the recipient opened the "field" a corrugated football literally popped up and out of the mailing.

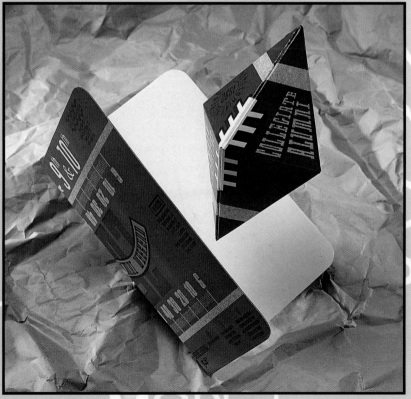

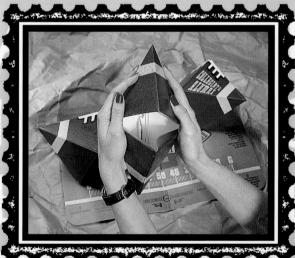

Since Love Packaging is a corrugated box manufacturer, they had the materials on hand. Love's structural designer, Daryl Hearne, took the original idea, extended the diamond into a football shape and devised internal corrugated hooks that would hold a high tension rubber band—which made the football pop up from a flattened shape.

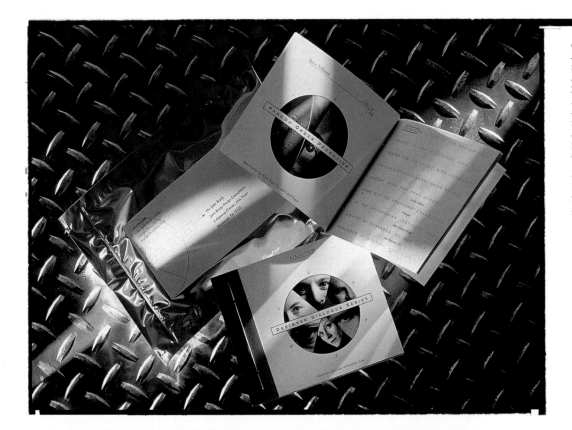

CLIENT:
AIGA/Pittsburgh
DESIGN FIRM:
John Brady Design Consultants
Pittsburgh, Pennsylvania
ART DIRECTOR:
John Brady
DESIGNER:
Joe Tomko
PHOTOGRAPHER:
Chris Caffee

Mailed in a silver mylar bag, this invitation attracted a large turnout for a series of breakfast lectures given by graphic designers.

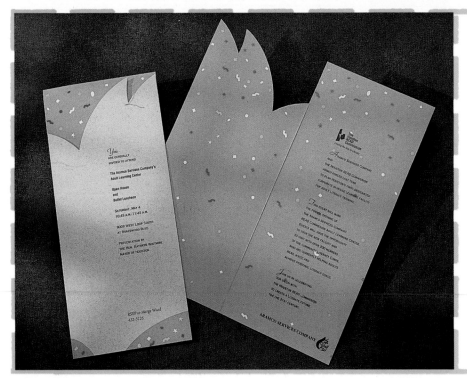

CLIENT:
Aranico Services/
The Read Commission
DESIGN FIRM:
Peat Jariya Design
Houston, Texas
ALL DESIGN BY:
Peat Jariya

The die-cut cover of this invitation reveals confetti graphics inside, enticing the reader to continue.

CLIENT:
Ad Federation of Wichita
DESIGN FIRM:
Love Packaging Group
Wichita, Kansas
ALL DESIGN BY:
Tracy Holdeman

Designed to promote the Wichita ADDY (advertising excellence) awards, this mailer arrives flat and is assembled by the recipient. The "Late Night Deadline with David Letterhead" theme is a take-off on a TV show.

CLIENT:
AGI, Inc.
DESIGN FIRM:
THIRST
Chicago, Illinois
ALL DESIGN BY:
Rick Valicenti
PHOTOGRAPHER:
Tom Maday

AGI, Inc.'s holiday card highlights a charity or cause of choice to which they contribute monies in the name of the recipient of the greeting card. This card depicted an inner-city Chicago school and its students. The school had no art or music supplies, but was able to purchase them for the upcoming year after this campaign.

CLIENT:
Dallas Society of Visual Communication
DESIGN FIRM:
Milton Bradley Graphic Arts
East Longmeadow, Massachusetts
ALL DESIGN BY:
Jim Bremer

This mailer to promote a talk by a game company executive features graphics taken entirely from packages and game components. Those attending the event were asked to bring a new toy to be given to charity.

CLIENT:
AIGA Boston
DESIGN FIRM:
Stoltze Design
Boston, Massachusetts
ALL DESIGN BY:
Clifford Stoltze
PHOTOGRAPHER:
Anton Grassl

Directed primarily at a design audience, this poster incorporates typography and color as well as photography to reflect the experimental attitude of the lectures.

CLIENT:
Western Regional Greek Conference
DESIGN FIRM:
**Sayles Graphic Design
Des Moines, Iowa**
ALL DESIGN BY:
John Sayles

This two-color brochure promotes a student conference. The brochure was mailed in a die-cut chipboard wrap.

CLIENT:
**Charlotte Society of
Communicating Arts**
DESIGN FIRM:
**Sayles Graphic Design
Des Moines, Iowa**
ALL DESIGN BY:
John Sayles

This two-color announcement invites members to hear the speakers "make their point." A pencil was included in the mailing!

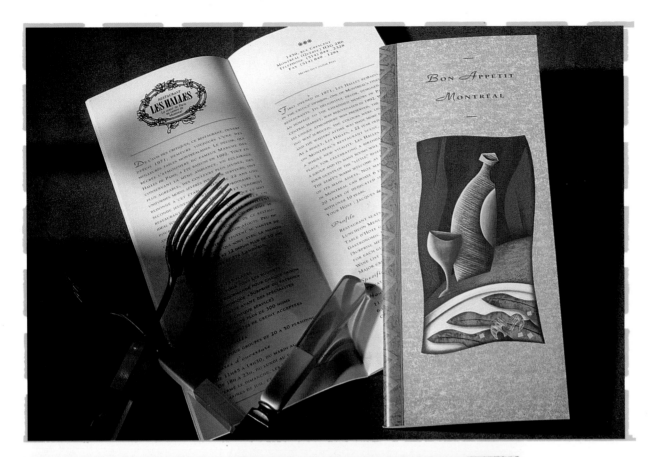

CLIENT:
Groupe Qualité Montréal
DESIGN FIRM:
PAPRIKA
Montréal, Québec Canada
ART DIRECTOR:
Louis Gagnon
DESIGNER:
Louis Gagnon
ILLUSTRATOR:
Jacques Cournoyer

This mailing was developed for an association of sophisticated restaurants in Montréal.

CLIENT:
Depelchin's Children Center
DESIGN FIRM:
Peat Jariya Design
Houston, Texas
ALL DESIGN BY:
Peat Jariya

Graphics in this one-color mailer reflect the "pinking shear" die-cut used on the cover.

CLIENT:
Boy Scouts of America
DESIGN FIRM:
Olson Johnson Design Company
Minneapolis, Minnesota
DESIGNER:
Dan Olson, Haley Johnson
ILLUSTRATOR:
Haley Johnson
PHOTOGRAPHER:
Paul Irmiter

The unusual string-binding of this annual report mailing compels the reader to open it. Inside, the text is a combination of typewritten and handwritten copy.

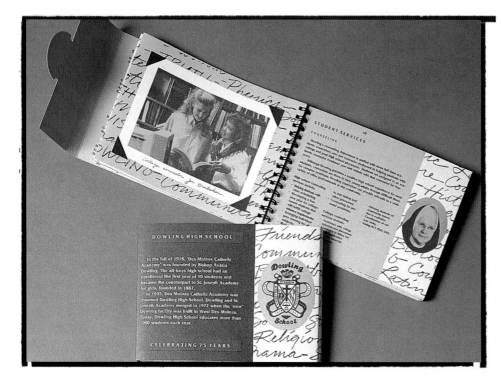

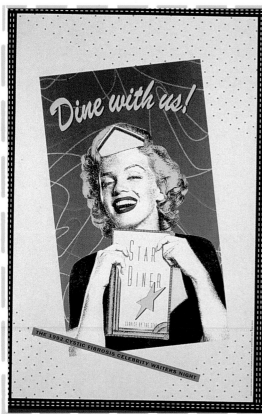

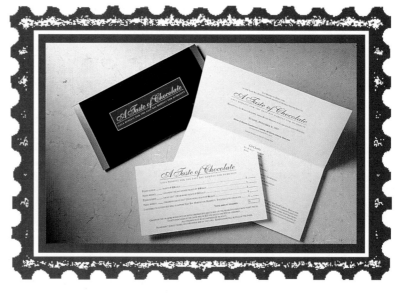

CLIENT:
Dowling High School
DESIGN FIRM:
Sayles Graphic Design
Des Moines, Iowa
ALL DESIGN BY:
John Sayles

Old photos, mixed with new ones, create a "keepsake/photo album" look for this high school prospectus.

CLIENT:
Habitat for Humanity
DESIGN FIRM: ·
Jon Wells Associates
San Francisco, California
DESIGNER:
Jon Wells

With a design that mimics a fine candy bar, this mailer is an invitation to "A Taste of Chocolate."

CLIENT:
Cystic Fibrosis Foundation
DESIGN FIRM:
Vaughn Wedeen Creative
Albuquerque, New Mexico
ALL DESIGN BY:
Rick Vaughn

Using a 1950s motif, this mailing mimics a diner menu. The inside layout carries the theme through.

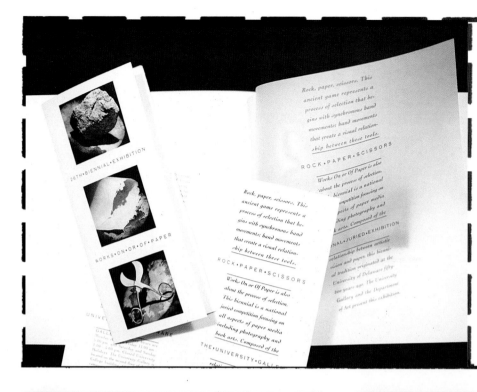

CLIENT:
Department of Art & University Gallery
DESIGN FIRM:
DEsigners
Newark, Delaware
ALL DESIGN BY:
Martha Carothers
PHOTOGRAPHER:
Nicholas Eveleigh

This mailing uses an interpretation of an ancient game as its theme. The mailing promotes a juried paper exhibition.

CLIENT:
The AIDS/HIV Life Center
DESIGN FIRM:
Sackett Design Associates
San Francisco, California
ART DIRECTOR:
Mark Sackett
DESIGNER:
Mark Sackett, Wayne Sakamoto

An invitation to an AIDS/HIV benefit event, the "Window to Life" theme is reflected in the visuals. Various photographers contributed their time and images for the nonprofit group.

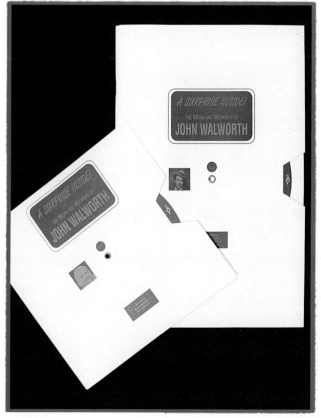

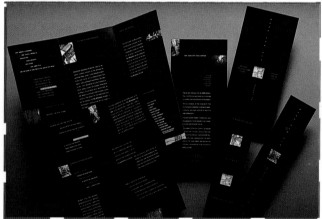

CLIENT:
University Gallery/University of Delaware
DESIGN FIRM:
The Post Press
Newark, Delaware
ART DIRECTOR:
Martha Carothers
DESIGNER:
Martha Carothers
ILLUSTRATOR:
John Walworth

The movable dial in this gallery catalog reveals 10 images as well as dates and descriptions.

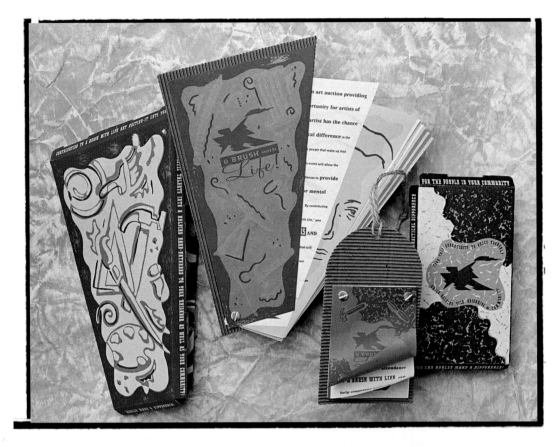

CLIENT:
Mental Health Association
DESIGN FIRM:
Love Packaging Group
Wichita, Kansas
ART DIRECTOR:
Tracy Holdeman
DESIGNER:
Brian Miller, Tracy Holdeman
ILLUSTRATOR:
Tracy Holdeman, Brian Miller

This project included a "Call for Art" directed to artists and a subsequent invitation to the Mental Health Association Art Auction. Along with the event information are instructions to bring the invitation to the auction for use as a "bidding paddle."

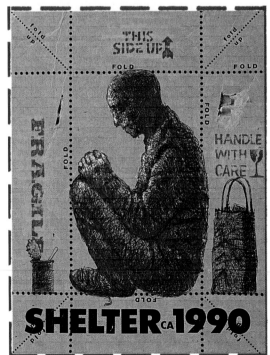

CLIENT:
Architects, Designers and Planners for Social Responsibility
DESIGN FIRM:
Kiyoshi Kanai Inc.
New York, New York
ALL DESIGN BY:
Kiyoshi Kanai

Part of a series, this postcard reflects the "shelter" theme adopted by the nonprofit group. The original art for the postcard was created on corrugated cardboard using permanent markers, then photographed.

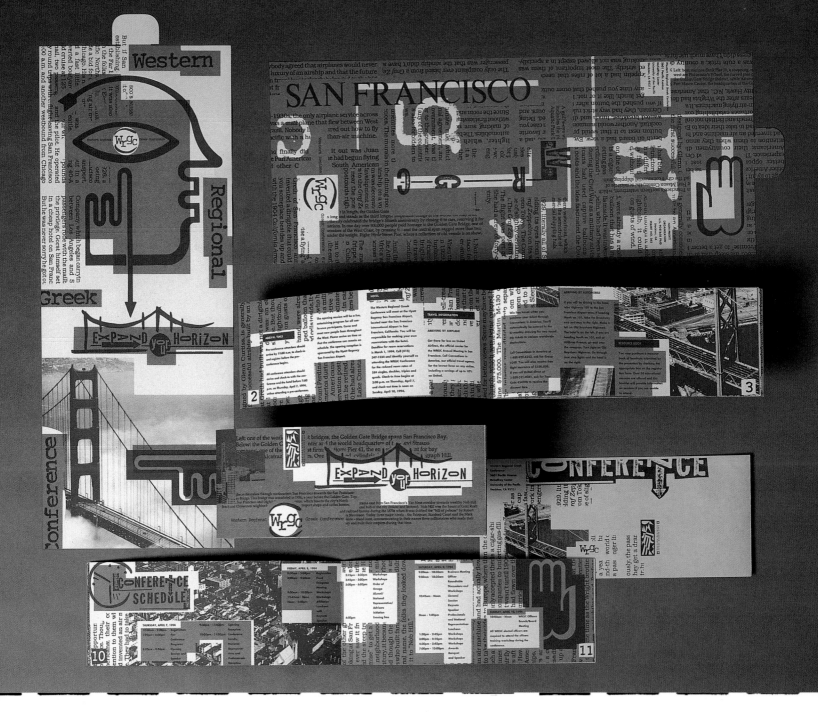

CLIENT:
Western Regional Greek Conference
DESIGN FIRM:
Sayles Graphic Design
Des Moines, Iowa
ALL DESIGN BY:
John Sayles

**Illustrations of bridges and a vertical format complete
the theme of this brochure, "Expand Your Horizon."**

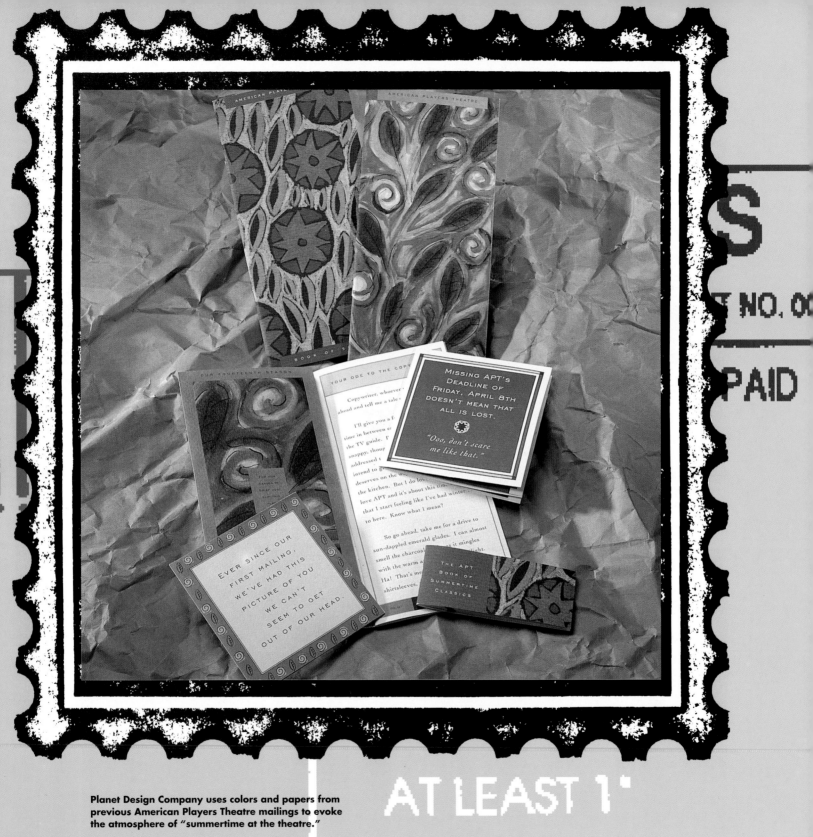

Planet Design Company uses colors and papers from previous American Players Theatre mailings to evoke the atmosphere of "summertime at the theatre."

Development/
Fund-raising
Mailings

Like business-to-consumer and business-to-business mailings, fundraising mailings face a great deal of competition. Mountains of charitable appeals are mailed each year. An effective fund-raising mailing often touches the recipient's emotions—it pulls on the heart-strings as well as the purse-strings. This type of mailing is usually not promoting a specific product or service. Rather, it requests the recipient's financial support in exchange for the satisfaction of helping a nonprofit organization reach a goal. The mailing must be refined but urgent in its appeal—and convince potential donors that an organization's cause is valid. If a fund-raising mailing is successful, it will make the audience believe in an organization so much that they write out a check.

Planet Design Company had an established relationship with American Players Theatre, a classical, Shakespearean theatre in Spring Green, Wisconsin. American Players Theatre offers a world-class entertainment experience on an outdoor stage. Planet Design had helped the organization sell tickets by creating a series of direct mail campaigns using rich colors and tactile paper that set the mood of "summertime at the theatre." Over a period of four years of working with Planet Design, the theatre's ticket sales had increased dramatically.

Then the organization's management decided to launch an even more ambitious fund-raising campaign. Their goal was to raise money to build a retractable canopy over the outdoor stage that would protect it and the audience from the elements. The Taliesin Architects and

TIPS FOR EFFECTIVE DIRECT MAIL DESIGN

1. **Think big.**
 A great concept is a must.

2. **Target markets.**
 Solve the client's marketing problem. Stay focused on what you're trying to accomplish. Don't do design for design's sake.

3. **TALK!**
 The client and designer should push each other creatively as they work toward a common goal.

4. **Plan ahead.**
 Put as much time as possible into the creative process.

5. **Combine design.**
 A successful direct mailing is a combination of many things ...including a client's vision, great design and illustration, and effective copywriting.

6. **Say when.**
 Go beyond the obvious, but don't be different just to be different.

renowned theatre designer George Izenour were brought in to design the canopy. Izenour had discovered archeological proof that ancient Greek and Roman outdoor theatres used retractable canopies. This concept hadn't been brought to light for thousands of years. If American Players Theatre could build one, it would attract national attention.

Most nonprofit organizations have limited development budgets, and this project was no exception: 750 dollars was the amount available for everything connected with the fund-raising campaign. The good news was that the very targeted donor list included only 10 recipients.

The resulting brochure is a work of art, reflective of the artistic nature of the client. The decision to donate money at the level being requested isn't an immediate one, so the brochure needed to be intriguing enough for the potential donor to save it. The brochure is made of deep, rich-colored paper and has a slipband protected by a rice paper envelope. The folded paper and slipband force the recipient to interact with the brochure—it's like opening a special gift. The brochure resembles a limited-edition, letterpressed book.

The fund-raising brochure was developed so the design firm could do the production themselves, to keep the costs down. Brochure text was set on a computer and reproduction was done on a photocopier. The publication was bound in-house, using a sewing machine to stitch pages together. The architect's initial drawings of the canopy were tipped in on a vellum paper stock. The client requested a picture of a project model be included in the brochure to give potential investors a look at how the money was to be spent. Since the designers' goal was to have the piece look and feel hand-made, a glossy photograph wouldn't do. Instead, an enlargement of the original 3x5 inch photograph was printed as a Polaroid transfer—a process that develops a Polaroid image directly on paper. This gave the photo the illustrative feel the designers were after.

The brochure's copy is elegant yet straightforward. Copywriter John Anderson involves the reader with intriguing information about the project—such as the Greek and Roman tradition of having a canopied theatre. Since the piece was targeted at theatre supporters, the remarkable achievement of having a one-of-a-kind, world-class facility in their community is a focal point of the appeal.

The American Players Theatre fund-raising brochure is successful because it truly embodies the fine art of the theatre. Both the client and the design firm are very proud of this piece. Because the theatre's canopy is a long-term project, the fund-raising process will be slow. But, potential donors presented with the brochure have been very impressed and have reacted positively. The brochure has created the desired response by symbolizing excellence and the achieve-ment of being one-of-a-kind. ■

CLIENT:
American Players Theatre
DESIGN FIRM:
Planet Design Company
Madison, Wisconsin
ART DIRECTORS:
Dana Lytle, Kevin Wade
DESIGNERS:
Dana Lytle, Martha Graettinger
COPYWRITER:
John Anderson
PHOTOGRAPHER:
Taliesin Architects, Mike Rebholz

The brochure was targeted to 10 potential major donors to the theatre's retractable canopy fund-raising campaign. The architect's drawing was included to clearly demonstrate the mechanics of the project.

The recipient removes a slipband from the book in order to get inside.

The finished product resembles a hand-bound, limited-edition book. It reflects the one-of-a-kind uniqueness of the theatre and the retractable canopy fund-raising project.

The brochures were created to be produced by the design firm in-house. Typesetting was done on a computer, and the brochures were reproduced by photocopying. The photograph of the model was accomplished by using a Polaroid-transfer process.

CLIENT:
Stewart Monderer Design, Inc.
DESIGN FIRM:
Stewart Monderer Design, Inc.
Boston, Massachusetts
ART DIRECTOR:
Stewart Monderer
DESIGNER:
Robert Davison, Jane Winsor
ILLUSTRATOR:
Mark Matcho

This brochure mailer carries its theme throughout, with visuals and copy. The pages are "french-folded," the cover is hand-glued.

CLIENT:
March of Dimes
DESIGN FIRM:
Sackett Design Associates
San Francisco, California
ART DIRECTOR:
Mark Sackett
DESIGNER:
Mark Sackett, Wayne Sakamoto
ILLUSTRATOR:
Mark Sackett, Wayne Sakamoto

A California chapter of the March of Dimes held a "Bid for Bachelors" fundraiser. The mailing indicated it was "for women only."

CLIENT:
Wichita Jazz Festival
DESIGN FIRM:
Love Packaging Group
Wichita, Kansas
ALL DESIGN BY:
Tracy Holdeman
PHOTOGRAPHER:
Rock Island Studios

This elaborate invitation falls open when the closure disk is lifted. Inside a rolled sheet contains details.

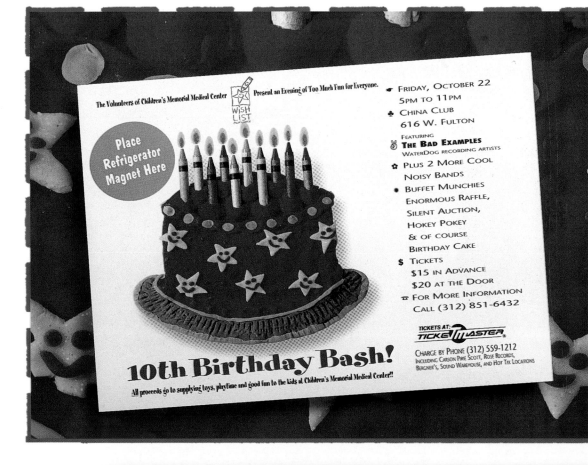

CLIENT:
Wish List Auxiliary/Children's Memorial Hospital Chicago
DESIGN FIRM:
Design Goddess International Chicago, Illinois
DESIGNER:
Deb Jansen
ILLUSTRATOR:
Play-doh© Sculpture Deb Jansen
PHOTOGRAPHER:
John Merkle

A Play-doh© sculpture is the visual for this benefit mailing. The child-like effect is appropriate: The event provides toys and art supplies to a children's hospital.

CLIENT:
University of Chicago Laboratory Schools
DESIGN FIRM:
Lipman Hearne Chicago, Illinois
ALL DESIGN BY:
Hal Kugeler
ILLUSTRATOR:
Stephen Schudlich
PHOTOGRAPHER:
Susan Reich

This interactive piece draws from the concept of building and is designed to be placed upright on a surface.

CLIENT:
The Asia Society
DESIGN FIRM:
Clifford Selbert Design
Cambridge, Massachusetts
ALL DESIGN BY:
Darren Namaye

When the Asia Society planned an ambitious fund raiser—34 simultaneous dinners, each with a specific theme, throughout Manhattan—they needed more than a simple invitation. They needed something that would sell the concept, making a large amount of information readable, while capturing the imagination and setting the tone for an unforgettable evening.

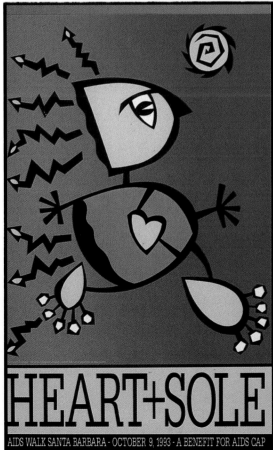

CLIENT:
AIDS Cap
DESIGN FIRM:
Puccinelli Design
Santa Barbara, California
ART DIRECTOR:
Keith Puccinelli
DESIGNER:
Keith Puccinelli, Heidi Palladino
ILLUSTRATOR:
Keith Puccinelli

This image, used as a signed and numbered limited edition serigraph, was given to major supporters. A smaller poster was used to advertise the event, and postcards were made to use for direct mail. All were screenprinted on the same parent sheet.

CLIENT:
DIFFA/Chicago
DESIGN FIRM:
Concrete
Chicago, Illinois
DESIGNER:
Jilly Simons, Susan Carlson, David Robson
PHOTOGRAPHER:
Peter Rosenbaum

Created for DIFFA (Design Industries Foundation for AIDS), this piece is an invitation to "Cocamalayo," a fund-raising ball. All creative fees, photography, paper, and printing were donated.

CLIENT:
Alley Theatre
DESIGN FIRM:
Rigsby Design, Inc.
Houston, Texas
DESIGNER:
Lana Rigsby
ILLUSTRATOR:
Lana Rigsby, Deborah Brochstein

Using a postage stamp motif, this invitation was designed for the Alley Theatre's Annual Gala.

CLIENT:
John Thomas Graziano Fundraising Committee
DESIGN FIRM:
THIRST
Chicago, Illinois
ART DIRECTOR:
Rick Valicenti
DESIGNER:
Richard Weaver
PHOTOGRAPHER:
Richard Weaver

Graffiti art is used as visuals for this fund-raising invitation.

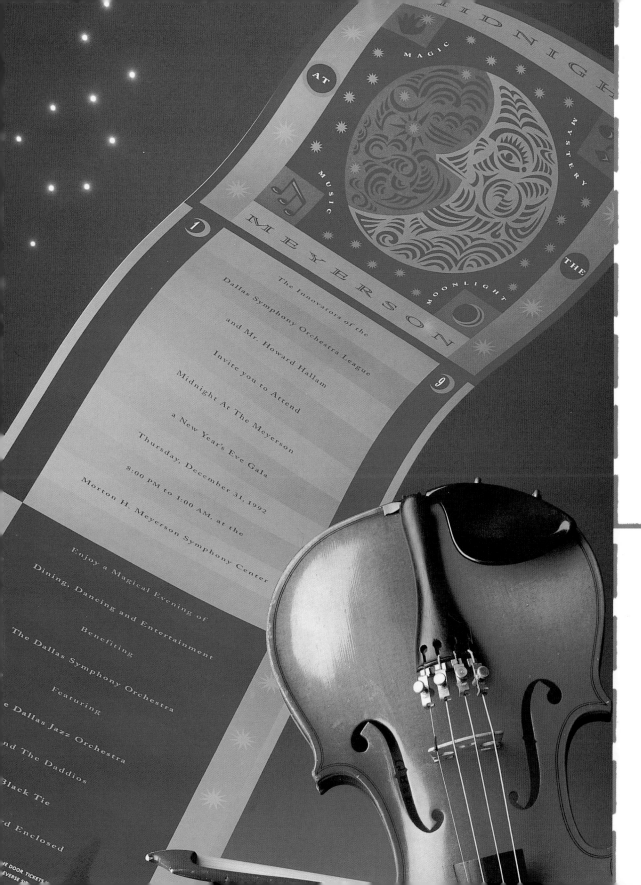

MAGIC

MYSTERY

MUSIC

MOONLIGHT

AT

THE

MIDNIGHT

MEYERSON

1 9

The Innovators of the

Dallas Symphony Orchestra League

and Mr. Howard Hallam

Invite you to Attend

Midnight At The Meyerson

a New Year's Eve Gala

Thursday, December 31, 1992

8:00 PM to 1:00 AM, at the

Morton H. Meyerson Symphony Center

Enjoy a Magical Evening of

Dining, Dancing and Entertainment

Benefiting

The Dallas Symphony Orchestra

Featuring

e Dallas Jazz Orchestra

nd The Daddios

Black Tie

rd Enclosed

E DOOR TICKETS
EVERSE SI

CLIENT:
Dallas Symphony Orchestra League
DESIGN FIRM:
Peterson & Company
Dallas, Texas
ALL DESIGN BY:
Jan Wilson

This invitation to a New Year's Eve gala reflects the "Midnight" theme with appropriate visuals and colors. The event was to benefit a symphony orchestra.

CLIENT:
Share Our Strength
DESIGN FIRM:
Hoinash + Associates
Princeton, New Jersey
ART DIRECTOR:
Molly Eklund-Huhn
DESIGNER:
Molly Eklund-Huhn, Lynne Hoinash
ILLUSTRATOR:
Lynne Hoinash

Four die-cut panels lend charm to this invitation. Limiting the number of inks to just two helped keep costs manageable.

CLIENT:
United Way of Dade County
DESIGN FIRM:
Blue Sky Design
Miami, Florida
ALL DESIGN BY:
Maria Dominguez, Robert Little
ILLUSTRATOR:
Reid Atwood

These dramatic, hand-assembled, red boxes demand immediate attention from the recipient. The components of the invitation, wrapped in a black band and embellished with a gold engraved crest, convey the importance of the event and the organization.

CLIENT:
Chicago House
DESIGN FIRM:
Segura Inc.
Chicago, Illinois
ALL DESIGN BY:
Carlos Segura
ILLUSTRATOR:
Joel Nakamura

An invitation to an AIDS benefit, this mail piece was printed on Japanese paper. The designer used more than one type of the imported paper in order to experiment with different effects.

CLIENT:
Cleveland Clinic Foundation
DESIGN FIRM:
Nesnadny + Schwartz
Cleveland, Ohio
ALL DESIGN BY:
Tim Lachina, Michelle Moehler
PHOTOGRAPHER:
Tony Festa

The softness of this visual creates an emotional appeal. Recipients are asked to support an area cancer clinic.

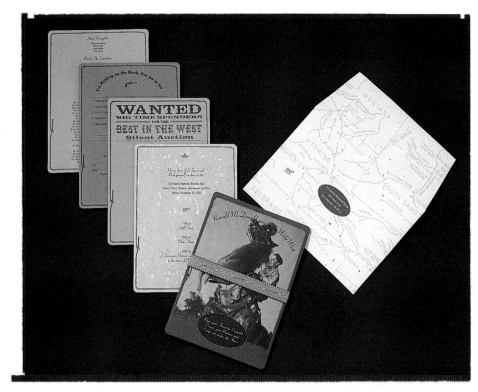

CLIENT:
Ronald McDonald House
DESIGN FIRM:
Cahan & Associates
San Francisco, California
ART DIRECTOR:
Bill Cahan
DESIGNER:
Sharrie Brooks

A pro bono invitation for an organization that supports children with cancer: The theme of the party was centered around cowboys, hence the typography and image used.

CLIENT:
Casey House Hospice
DESIGN FIRM:
Concrete Design Communications Inc.
Toronto, Ontario Canada
ART DIRECTOR:
Diti Katona, John Pylypczak
DESIGNER:
Scott A. Christie
PHOTOGRAPHER:
Ron Baxter Smith

Created for a Toronto AIDS care group, "Laughing Matters" posters and invitations heralded a casual fund-raising event where comedians entertained and partygo-ers could bid on photos of famous Canadians laughing. The simple design, reproduced on an inexpensive, newsprint-like stock, kept costs at rock-bottom and added to the event's casual atmosphere.

CLIENT:
Dowling High School
DESIGN FIRM:
Sayles Graphic Design
Des Moines, Iowa
ALL DESIGN BY:
John Sayles
PHOTOGRAPHER:
Scott Sinklier

Using the theme "A Season of Growth," this fund-raising brochure uses plant graphics and spot plant icons. The vintage photos used are from the high school's archives.

CLIENT:
Iowa Association of Auto Dealers
DESIGN FIRM:
**Sayles Graphic Design
Des Moines, Iowa**
ALL DESIGN BY:
John Sayles

To raise money for its political action committee, an association of auto dealers sent a die-cut mailer proclaiming "You Hold the Key!" A follow-up postcard urges donors to "Give us a jump start."

CLIENT:
Iowa Medical Society
DESIGN FIRM:
**Sayles Graphic Design
Des Moines, Iowa**
ALL DESIGN BY:
John Sayles

The outside of the mailer tells the recipient "The wrong legislation could be a bitter pill to swallow." Inside, a vial of Sweet Tart candies completes the concept.

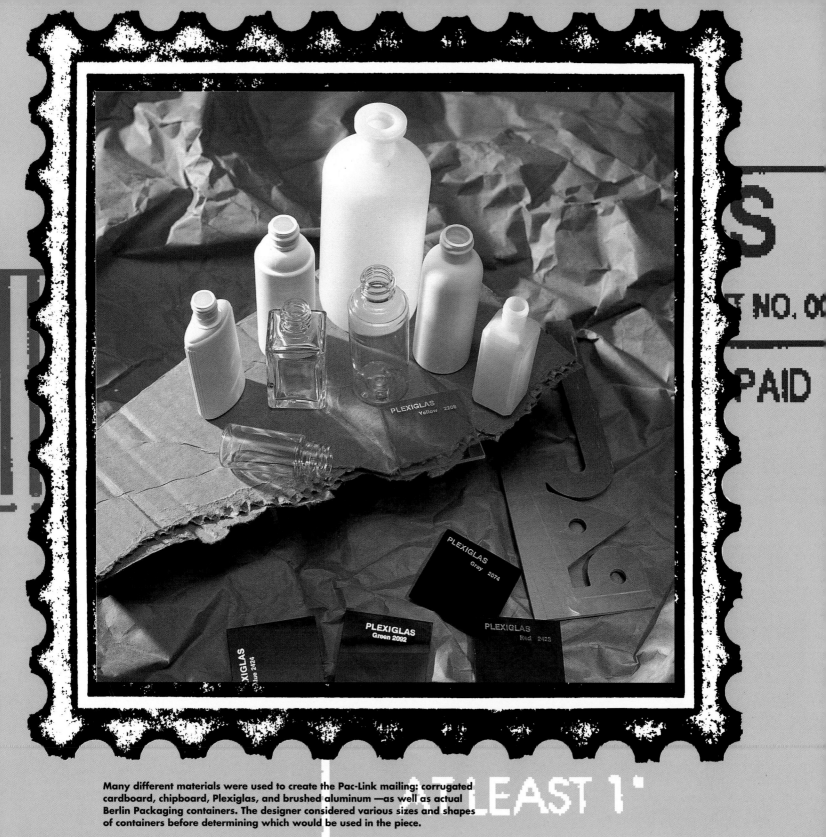

Many different materials were used to create the Pac-Link mailing: corrugated cardboard, chipboard, Plexiglas, and brushed aluminum —as well as actual Berlin Packaging containers. The designer considered various sizes and shapes of containers before determining which would be used in the piece.

3-D Direct Mail Design

When is a box not just a box? When it's a direct mail brochure! Sayles Graphic Design in Des Moines, Iowa, has become known for creating three-dimensional direct mail that gets attention. . .and gets results.

Results are exactly what Berlin Packaging Company got with Sayles' design for their three-dimensional direct mail brochure. One of the United States' largest suppliers of glass, plastic, and metal containers, Berlin needed a direct mail piece that would persuade 50 key accounts to come on-line with a new computerized order system called Pac-Link.

The goal of the mailing was to get Berlin's customers interested enough in Pac-Link to send back a reply card requesting more information. The result of the mailing was an avalanche of reply cards. "They poured in,"said Berlin's Vice President for Marketing, "response was overwhelming. Many customers liked the mailing design so much that they put it on display. Most important, our account staff got appointments and customers signed on for Pac-Link."

One of the reasons Sayles chose a 3-D design format was the mailing's target audience: decision makers for key accounts. An ordinary envelope may never make it past the secretary. When a package arrives, however, it looks like something special and it gets special treatment. That's the key. Berlin's unique package stood out from the ordinary mail, and Berlin's message got past the gatekeepers.

Designing in three-dimensions is effective, but it can be costly. Since Berlin only needed to target their top

TIPS FOR EFFECTIVE DIRECT MAIL DESIGN

1. **Break limits.**
 Don't limit yourself to two dimensions.

2. **Stand out.**
 An envelope is like a billboard for a company: Make it an unusual size, shape, or color, or print it on a unique medium so it really jumps out. Use great graphics or "hook" copy to entice the recipient to open it!

3. **Get their attention.**
 With a whisper or a shout—just get their attention—or you won't sell anything.

4. **Break out of an industry's norm.**
 Know what other companies are doing with their direct mail, but remember...what worked yesterday won't always work tomorrow.

5. **Leave them wanting more!**
 Hold back something about the company or product in the first mailing.

6. **Get the facts.**
 Don't be too quick to abandon a good idea because of logistics or assume a three-dimensional piece will cost too much to mail. Call the U.S. Postal Service and find out!

50 accounts, Sayles' design could pull out all the stops. The three-dimensional brochure features a multicolored Plexiglas™ unit that uses Berlin's packaging products in an extraordinary way. The display piece holds three samples of Berlin's containers...one metal, one plastic, and one glass, and the Pac-Link logo is fabricated from brushed aluminum. The entire display is mailed in a corrugated box printed with a five-color design. Copy printed on the back of the Plexiglas display and inside the box lid explains the selling points of Pac-Link. Key words and graphics printed on each container label highlight Pac-Link's features.

Sayles was creatively inspired by Berlin's diverse product line—which contains everything from toothpaste tubes to 55-gallon drums—and decided to include samples of three different containers in the mailing. The design challenge was in joining the samples together. What would make the message come full circle? Since Pac-Link is the service Berlin's customers can use to order packaging, introducing it with a Plexiglas showcase of Berlin's packages made sense.

The use of bright colors and innovative materials in the mailing elicits the feeling that Berlin is a forward-thinking company. Integrating samples of actual Berlin packages into the design reinforces the sales pitch. The goal was to create a direct mail piece the client would save and display—thus lengthening the life of Berlin's message. The display's longevity has another benefit; if the client doesn't send back the reply card the day they receive the package, the display sitting in their office acts as a reminder.

In creating the Pac-Link direct mail piece, Sayles brought together services and materials from five different sources: a box manufacturer, a chipboard company, Plexiglas from a plastics company, brushed

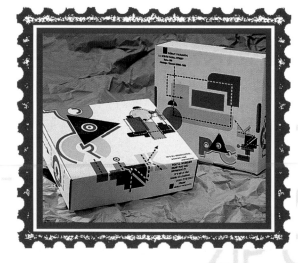

CLIENT:
Berlin Packaging
DESIGN FIRM:
**Sayles Graphic Design
Des Moines, Iowa**
DESIGNER:
John Sayles
COPYWRITER:
Wendy Lyons

Bold graphics and a three-dimensional shape helped to get the mailing past the recipients' "gate-keepers" and into the decision-makers' hands.

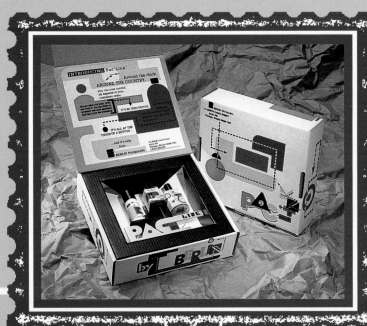

Once the recipient opened the mailing, the visual impact and uniqueness of the piece made the person want to read the copy and discover what Pac-Link was all about.

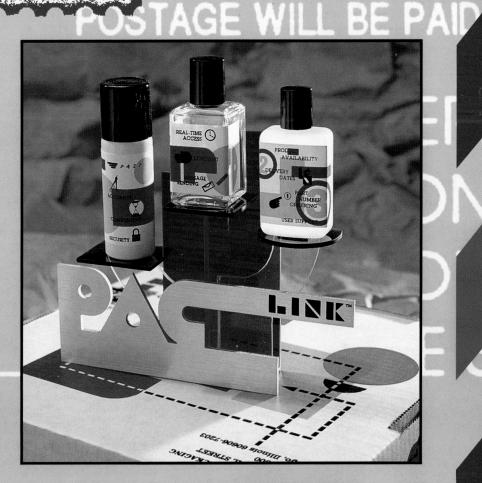

The containers chosen for this three-dimensional mailing represent the client's packaging. Small bottles were glued with silicone adhesive to a Plexiglas stand. Copy on the back of the piece explains the benefits of Pac-Link, a computerized ordering system.

7. Check postal regulations.
Have prototype mail pieces approved by the post office's Mailing Requirements department BEFORE printing. If the post office refuses to deliver a company's 10,000-piece direct mail campaign, you've got a disaster on your hands.

8. Plan ahead.
It saves time and money. For example, when the Berlin Pac-Link project was produced, extra boxes were printed. Berlin later used these boxes to mail Pac-Link manuals to clients who signed up for the service. These so-called "gang runs" really save on production costs.

9. Update your mailing list.
Businesses should always make sure their mailing list is accurate and on-target. A great mailing can't overcome a bad mailing list.

aluminum for the logo, and container samples from Berlin. Keeping each supplier on time and on budget was a challenge; everyone involved in the project used blueprints to make sure pieces fit together smoothly, as if they'd come from a single source.

But the Pac-Link mailing didn't just look pretty...the recipient had to read the copy, or the mailing would not get results. Sayles' copywriter backed up exciting visuals with "teaser" copy. Since the mailing was aimed at decision makers who probably wouldn't take time to read lots of text, the copy only briefly explains the benefits of Pac-Link. The whole idea behind the Pac-Link piece was to entice the reader into wanting more information, and into sending back the reply card.

The Sayles staff was not surprised at the Pac-Link mailing's success. Sayles explains, "I enjoy designing direct mail because of the challenge of getting a response. I want the person who gets the mailing to feel something. Three-dimensional mailings force the reader to interact with them. There is a greater chance of getting an emotional response when you send someone a box to open. It's like getting a present!" ■

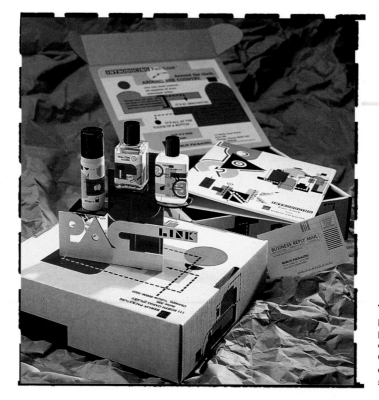

The Pac-Link mailing was part of a campaign to promote a computerized on-line ordering service. Other components included a user's manual and support materials.

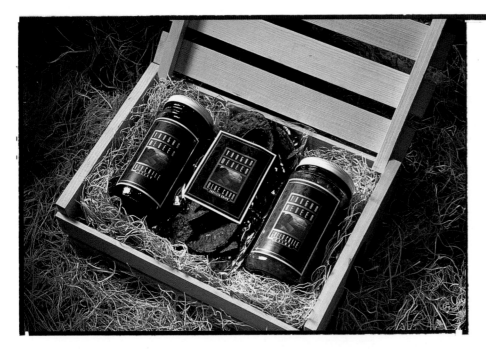

CLIENT:
Vaughn Wedeen Creative
DESIGN FIRM:
Vaughn Wedeen Creative
Albuquerque, New Mexico
DESIGNER:
Daniel Michael Flynn

An advertising/design firm located in Albuquerque, New Mexico, created this Christmas promotion. A gift of tortilla chips and salsa captured the flavor of the firm's work and locale.

CLIENT:
Vaughn Wedeen Creative
DESIGN FIRM:
Vaughn Wedeen Creative
Albuquerque, New Mexico
DESIGNER:
Daniel Michael Flynn
ILLUSTRATOR:
Gerhold/Smith

A holiday gift/mailer from a design firm, this box contains vinegar and chutney with a beautiful custom label.

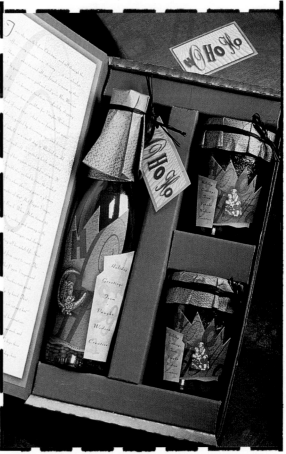

CLIENT:
Gary and O.J. Shansby
DESIGN FIRM:
Bielenberg Design
San Francisco, California
ALL DESIGN BY:
John Bielenberg

This unusual wedding invitation was screenprinted onto a sheet of 1/2" thick acrylic!

CLIENT:
John Brady Design Consultants
DESIGN FIRM:
John Brady Design Consultants
Pittsburgh, Pennsylvania
ART DIRECTOR:
John Brady
DESIGNER:
Gina Kennedy

This memorable and cost-effective Halloween promotion included a real bulb of garlic.

CLIENT:
Nottage and Ward
DESIGN FIRM:
Concrete
Chicago, Illinois
DESIGNER:
Jilly Simons, David Robeson
PHOTOGRAPHER:
Francois Robert

This announcement for a legal practice, entitled "Gentle Peace," is successful because its judicious use of language, imagery, and materials communicates the firm's sensitivity to the individual needs of its clients.

CLIENT:
AIGA Washington
DESIGN TEAM:
Melanie Bass, Julie Sebastianelli, Richard Hamilton, Jim Jackson, Jake Pollard, Andres Tremols, Pam Johnson

The ideal vehicle to introduce a series of animated films: a flip book!

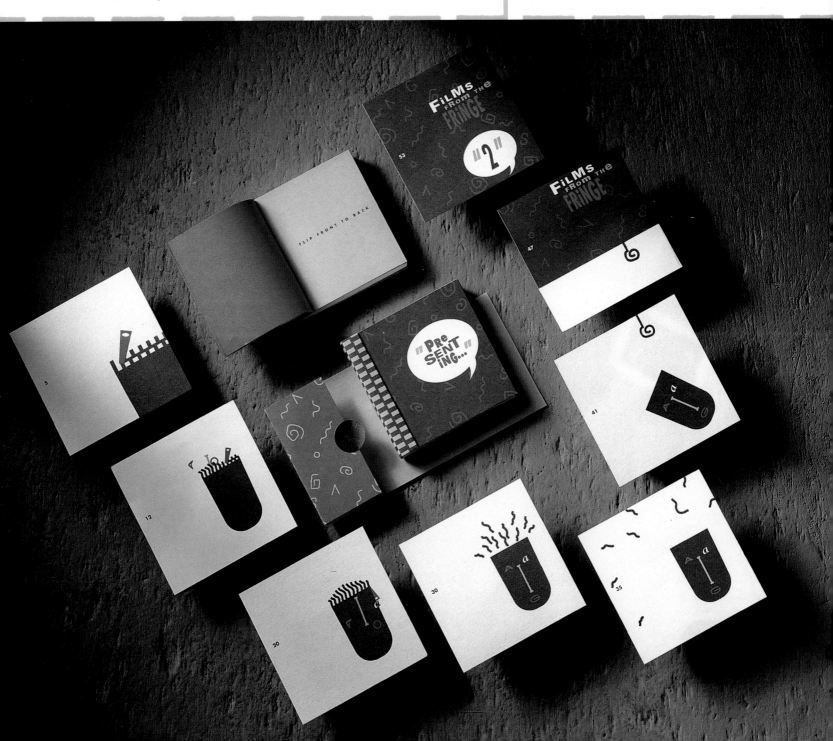

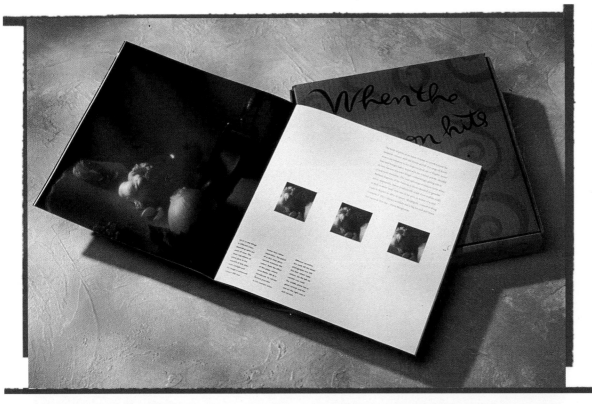

CLIENT:
Island Paper Mills
DESIGN FIRM:
HerRainco Design Associates Inc.
Vancouver, BC, Canada
ART DIRECTOR:
Ray Hrynkow
DESIGNER:
Ray Hrynkow
ILLUSTRATOR:
Kathy Boake

Mailed in a mock pizza box, this promotional mailer uses appropriate photography throughout.

CLIENT:
Vaughn Wedeen Creative
DESIGN FIRM:
Vaughn Wedeen Creative
Albuquerque, New Mexico
ALL DESIGN BY:
Rick Vaughn, Steve Wedeen

A self-promotion for a design firm, this custom piece is plastic wire-o bound. Images inside are matted for an "album" effect.

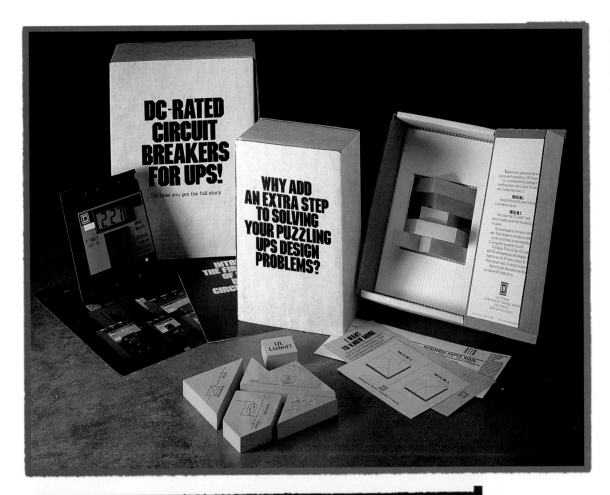

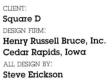

CLIENT:
Square D
DESIGN FIRM:
Henry Russell Bruce, Inc.
Cedar Rapids, Iowa
ALL DESIGN BY:
Steve Erickson

Two mailings to promote a circuit breaker company: one includes a personalized clock, the other features a wooden puzzle. Copy points underscore the theme of each mailing.

CLIENT:
Tom Fowler, Inc.
DESIGN FIRM:
Tom Fowler, Inc.
Stamford, Connecticut
ALL DESIGN BY:
Thomas G. Fowler

This invitation—a wooden box with a Lucite lid—is compelling. After the event is over, the box remains as a keepsake.

Three-Dimensional Direct Mail 139

CLIENT:
Tom Fowler, Inc.
DESIGN FIRM:
Tom Fowler, Inc.
Stamford, Connecticut
ALL DESIGN BY:
Thomas G. Fowler

This invitation arrives wrapped in a brown corrugated cardboard sleeve. The words 'tic tic tic' are repeated around the sleeve to get the viewer to open up the package to see what is 'ticking.' The recipient soon realizes the box itself is a clock and an invitation to a holiday party.

CLIENT:
H.T. Woods
DESIGN FIRM:
Tom Fowler, Inc.
Stamford, Connecticut
ART DIRECTOR:
Thomas G. Fowler
DESIGNER:
Thomas G. Flower, Karl S. Maruyamam
PHOTOGRAPHER:
Randy Duchaine

Wrapped in a band of handmade paper, this brochure is nested in a custom, wooden box.

CLIENT:
Pomona College
DESIGN FIRM:
McMonigle & Spooner
Monrovia, California
ALL DESIGN BY:
Stan Spooner
PHOTOGRAPHER:
Gene Sasse

Calendar mailings can be especially effective because of their potential reuse by the recipient. This one is wire-bound.

CLIENT:
Asymetrix Corporation
DESIGN FIRM:
**Hornall Anderson Design Works
Seattle, Washington**
ART DIRECTOR:
Jack Anderson
DESIGNER:
**Jack Anderson, Julie Tanagi-Lock,
Denise Weir**

An announcement for a software developer's new ToolBook product unveiling, the design solution for this piece visually interprets and reflects the program's offerings.

CLIENT:
Weyerhaeuser
DESIGN FIRM:
**Hornall Anderson Design Works
Seattle, Washington**
ART DIRECTOR:
Jack Anderson, John Hornall
DESIGNER:
**Jack Anderson, John Hornall,
Cliff Chung**

The spirit of this invitation was developed from the trade show's locale, the Atlanta High Museum. It also serves as a keepsake of the reception it represented.

CLIENT:
Grafik Communications Ltd.
DESIGN FIRM:
Grafik Communications Ltd.
Alexandria, Virginia
DESIGN TEAM:
Melanie Bass, Gregg Glaviano,
Jennifer Johnson, Judy Kirpich,
Julie Sebastianelli
ILLUSTRATOR:
Bob James, Evangelia Philippidis

**This mailing was developed in place
of a traditional greeting card to demon-
strate that the firm sending the piece
can come up with a very original idea
to market a product.**

CLIENT:
Supon Design Group, Inc.
DESIGN FIRM:
Supon Design Group, Inc.
Washington, D.C.
ART DIRECTOR:
Supon Phornirunlit, Andrew Dolan
DESIGNER:
Richard Boynton
ILLUSTRATOR:
Patrick O'Brien
PHOTOGRAPHER:
Oi Veerasarn

**Based on a time capsule concept, this
mailing contains a series of cards
"from another time."**

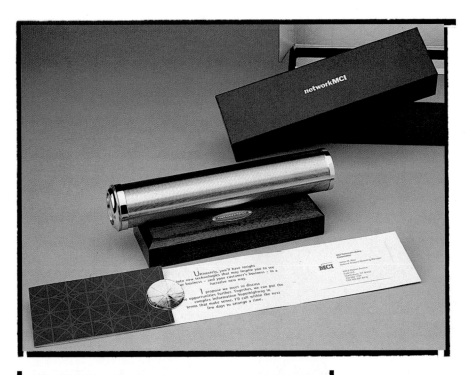

CLIENT:
MCI
AGENCY:
IQ&J Group 121
Boston, Massachusetts
CREATIVE DIRECTOR:
Mark Wilson
ART DIRECTOR:
Mark Wilson
COPYWRITER:
Holly Madden

**This mailing was sent to senior level executives. Represent-
atives who followed-up by phone, secured meetings with
40 percent of the prospective clients within the first week of
delivery.**

CLIENT:
IQ&J Group 121
AGENCY:
IQ&J Group 121
Boston, Massachusetts
CREATIVE DIRECTOR:
Rich Person
ART DIRECTOR:
Robert Davis
COPYWRITER:
John Wolfarth

**A one-of-a-kind mailing, this piece was sent to the market-
ing director at a hotel chain to suggest a meeting. It worked.**

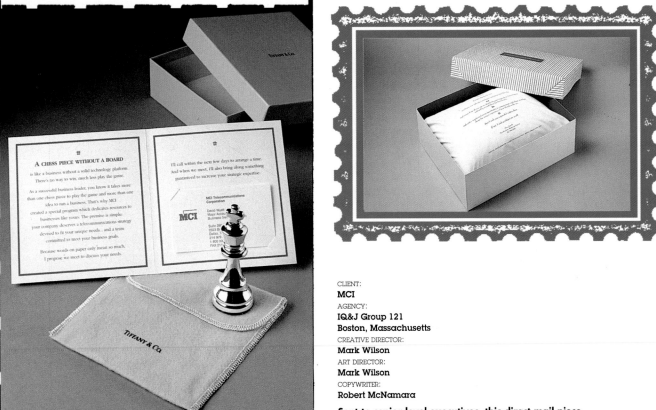

CLIENT:
MCI
AGENCY:
IQ&J Group 121
Boston, Massachusetts
CREATIVE DIRECTOR:
Mark Wilson
ART DIRECTOR:
Mark Wilson
COPYWRITER:
Robert McNamara

**Sent to senior level executives, this direct mail piece
yielded an impressive 63 percent response rate.**

CLIENT:
Tom Fowler, Inc.
DESIGN FIRM:
Tom Fowler, Inc.
Stamford, Connecticut
ALL DESIGN BY:
Thomas G. Fowler

Once unfolded, this unusual invitation expands to over 40 inches. It is wrapped in a custom, corrugated cardboard sleeve with a colorful graphic seal establishing the look for the inside panels.

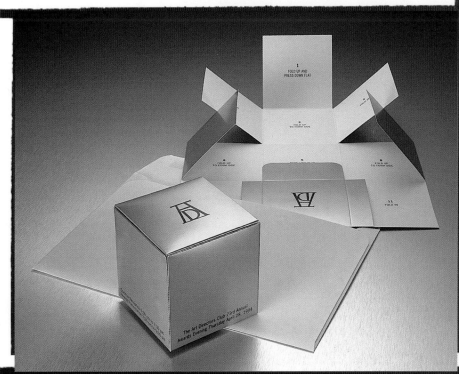

CLIENT:
The Art Directors Club
ART DIRECTOR:
Jean Govoni
Sag Harbor, New York
DESIGNER:
Jean Govoni
PHOTOGRAPHER:
Ted Morrison, Halley Ganges

Arriving flat in a 6x9" envelope, this invitation folds into a paper replica of the awards to be given at the ceremony. Event information is printed on the sides of the cube.

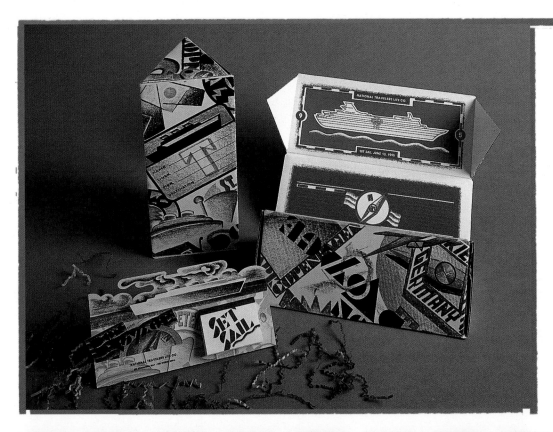

CLIENT:
National Travelers Life
DESIGN FIRM:
Sayles Graphic Design
Des Moines, Iowa
ALL DESIGN BY:
John Sayles

Four-color illustrations of travel stickers adorn this triangular mailer. Inside, a three-dimensional calendar is kept in place with bright confetti.

CLIENT:
Peter Lord
DESIGN FIRM:
Principal Communications
New York, New York
DESIGNER:
Peter Lord

This mailer is Volume I of a digital portfolio which features over 20 color and black-and-white logos in a self-running application.

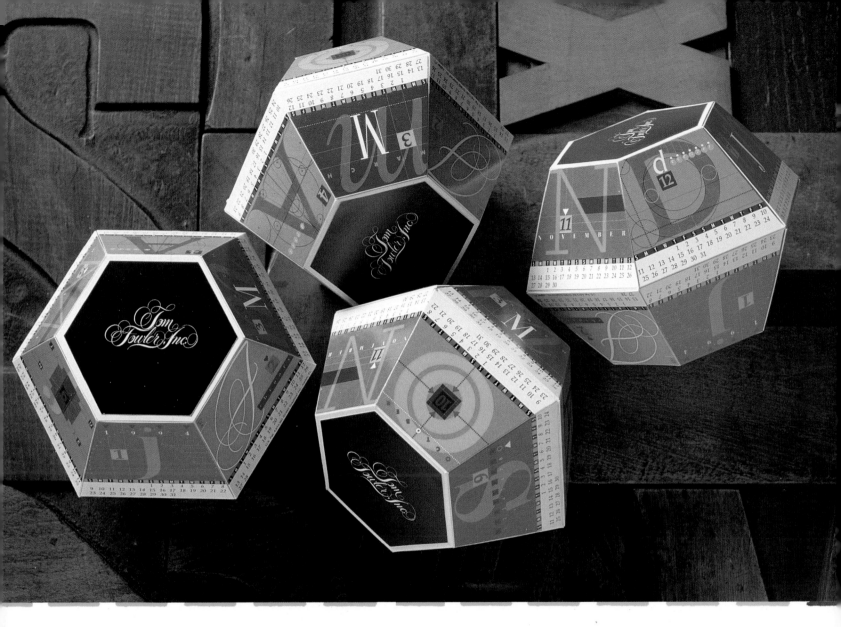

CLIENT:
Tom Fowler, Inc.
DESIGN FIRM:
Tom Fowler, Inc.
STAMFORD, CONNECTICUT
ALL DESIGN BY:
Thomas G. Fowler

A rubber band inside makes these calendars pop-up instantly when removed from their envelopes.

CLIENT:
IQ&J Group 121
DESIGN FIRM:
IQ&J Group 121
Boston, Massachusetts
CREATIVE DIRECTOR:
Rich Person
ART DIRECTOR:
John Bartley, Mark Wilson
COPYWRITER:
Holly Madden

This one-of-a-kind approach has worked very well for advertising agencies and design firms because the message is very tailored.

CLIENT:
Norwest Financial, Inc.
DESIGN FIRM:
Norwest Financial In-House
Des Moines, Iowa
ART DIRECTOR:
Barry Norgaard

In keeping with a nautical theme, the can of sardines is a historical reference to John Steinbeck's book "Cannery Row," which takes place in Monterey. Later mailings disclose the location of the conference.

CLIENT:
Broadcast Designer's Association
DESIGN FIRM:
Supon Design Group, Inc.
Washington, D.C.
ART DIRECTOR:
Supon Phornirunlit, Andrew Dolan
DESIGNER:
Andrew Dolan
ILLUSTRATOR:
Andrew Dolan

Bold and graphic illustrations representing the broadcast industry were used in this mailer to promote a broadcast designers competition. The box contained a video-tape of competition winners.

CLIENT:
McMonigle & Spooner
DESIGN FIRM:
**McMonigle & Spooner
Monrovia, California**
ALL DESIGN BY:
Stan Spooner

**The advantage to this type of
mailing is the long life of the
message. The recipient can use
these Christmas lights again
and again.**

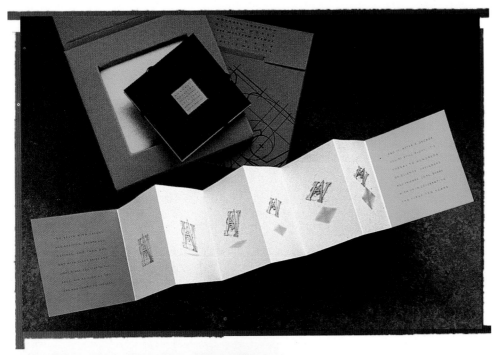

CLIENT:
Hornall Anderson Design Works
DESIGN FIRM:
Hornall Anderson Design Works
Seattle, Washington
ART DIRECTOR:
Jack Anderson
DESIGNER:
Jack Anderson, David Bates, Lian Ng,
Leo Raymundo, Paula Cox

This anniversary announcement was designed to survive as a keepsake that remained on the desk of the busy executive. This lingering after-use provides a long-term promotional opportunity for the sender.

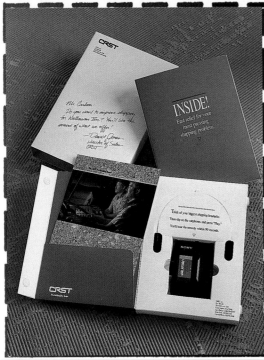

CLIENT:
CRST
DESIGN FIRM:
Henry Russell Bruce
Cedar Rapids, Iowa
ART DIRECTOR:
Mark Keele
CREATIVE DIRECTOR:
Steve Erickson
PHOTOGRAPHER:
Mike Schlotterback

Talk about a custom mailing! Targeted to key accounts, this kit contained a Walkman and personalized sales message.

CLIENT:
Vaughn Weeden Creative
DESIGN FIRM:
Vaughn Wedeen Creative
Albuquerque, New Mexico
ART DIRECTOR:
Rick Vaughn, Steve Wedeen,
Daniel Michael Flynn
DESIGNER:
Daniel Michael Flynn
ILLUSTRATOR:
Daniel Michael Flynn

Santa sent a selection from his private reserve for this holiday greeting.

CLIENT:
Hillside Development Corp.
DESIGN FIRM:
Sayles Graphic Design
Des Moines, Iowa
ALL DESIGN BY:
John Sayles

A three-dimensional version of the Hillside logo was fashioned out of acrylic and mailed as a promotion. The response was overwhelming.

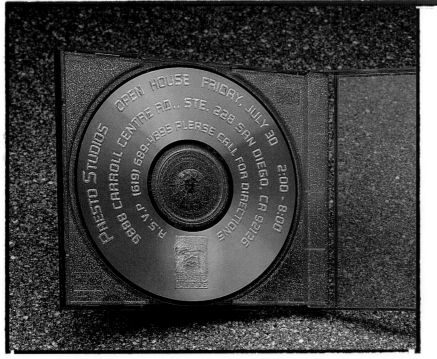

CLIENT:
Presto Studios
DESIGN FIRM:
Visual Eyes
Encinitas, California
ALL DESIGN BY:
E.J. Dixon III

An appropriate medium for Presto Studios' open house invitation is this compact disc mailing. The CD is laser-carved.

5/8"

NESS REPLY MAIL

MAIL PERMIT NO. 00000 ANYTOWN STATE

WILL BE PAID BY ADDRESSEE

AT LEAST 1"

NO
MORE

Biographies

Carlos Segura *Principal*
Segura, Inc.
361 West Chestnut Street
First Floor
Chicago, Illinois 60610
Phone: (312) 649-5688
Fax: (312) 649-0376

Supon Phornirunlit *Principal*
Supon Design Group, Inc.
1700 K Street, NW
Suite 400
Washington, D.C. 20006
Phone: (202) 822-6540
Fax: (202) 822-6541

David Carter *Principal*
David Carter Design Associates
4112 Swiss Avenue
Dallas, Texas 75204
Phone: (214) 826-4631
Fax: (214) 827-1938

Carlos Segura is not afraid of change. After moving from his hometown of Miami to the less-tropical city of Chicago, Segura worked for several advertising agencies before establishing his own firm in 1990. His firm has done work for such notable clients as Ernst & Young, Tommy Boy Records, Photonica, and Argus Press. Segura, Inc. has received awards from nearly every national and international creative competition.

Segura says his work is guided by a simple philosophy: Communication that doesn't take a chance . . . doesn't have a chance. This philosophy shows in everything Segura does, including direct mail design. The designer says of his staff, "We don't just accept a creative assignment. We attack it."

Segura recently established [T-26], a digital type foundry, with partner Scott Smith. The company offers computer fonts created by designers worldwide. [T-26] has grown phenomenally, due in part to the success of the direct mail sales kit designed by Segura and Smith.

See Segura Inc.'s unique [T-26] direct mail project on pages 9-11.

Supon Phornirunlit established Supon Design Group, Inc. in a one-bedroom apartment in 1988. Under his management, the company has enjoyed steady growth and is now comprised of a staff of 12 and three divisions: the graphic design studio, International Book Division, and newly-introduced product division.

Supon devotes much of his time to furthering the interests of graphic designers around the world. He has served on the Board of Directors of the Art Directors Club of Metropolitan Washington and on the Board of Directors of the Broadcast Designers' Association. He regularly serves as a judge for recognized design competitions and speaks at design conferences worldwide.

Supon's studio awards number over 400 to date, and include the Gold Award from AIGA/Baltimore, the Silver Award from *Studio* magazine's Design Annual and Gilbert Paper's Golden Quill Award. Supon Design Group's works have appeared in every major industry publication.

Supon's design work has been exhibited in Thailand—his native country—Germany, Japan, England, and Israel.

See Supon Design Group's business-to-business direct mailing for Black Entertainment Television on pages 25-27.

As founder and president of David Carter Design Associates, David Carter has built his company into one of today's leading international print and environmental graphic design firms. Since its beginning in 1981, the firm has grown to employ 20 designers, project managers, and administrative staff. Carter's award-winning design group has traveled across the globe to regions of the Caribbean, Europe, Africa, Southeast Asia, Australia, and throughout North America. They have been instrumental in designing graphics for hotels and resorts, fantasy theme parks, entertainment complexes, franchise restaurants, and other corporate ventures. Clients include The Lanesborough, Hyde Park, London; The Regent Beverly Wilshire, Beverly Hills; Walt Disney World, Florida; and various Grand Hyatts in Hong Kong, Taipei, Bali, and Bangkok.

Carter's career encompasses more than 20 years of graphic design experience. He is an active member of the Dallas Society of Visual Communications, having served on the Board of Directors, and is associated with the Art Institute of Dallas, serving on the Advisory Board. Carter is also a member of the American Institute of Graphic Arts and the Society of Environmental Graphic Designers.

See David Carter Design Associates' holiday invitation/announcement on pages 41-43.

Bruce Bennett *Senior Art Director*
K&D Bond Direct
3rd Floor
8 Kippax Street
Surry Hills NSW 2010, Australia
Phone: (02) 288-9000
Fax: (02) 281-6121

Wendy Pressley-Jacobs *Principal*
Pressley Jacobs Design, Inc.
101 North Wacker Drive
Suite 100
Chicago, Illinois 60606
Phone: (312) 263-7485
Fax: (312) 263-5419

Jack Anderson *Partner*
Hornall Anderson Design Works, Inc.
1008 Western
Sixth Floor
Seattle, Washington 98104
Phone: (206) 467-5800
Fax: (206) 467-6411

Art Director Bruce Bennett is Norwegian by birth, British by citizenship, and Australian by residency. His work has taken him to London, the Middle East, and the United States. Australia is his latest adopted country, and he is enjoying every second of it.

Part of the Kobs and Draft organization, K&D Bond Direct was founded by Ian Kennedy 16 years ago. From humble beginnings as a mail order merchandising company, K&D Bond Direct has developed into the second largest direct response agency in Australia.

The firm's clients include Avis, Bayer, Polaroid, and Pizza Hut. Among K&D Bond's awards are the John Caples International Award. The firm was also a finalist in the New York Festivals.

Bennett enjoys direct mail because of the union between design and advertising. He likes the challenge of gaining the target audience's attention and the creativity involved in using unusual formats and thinking outside the square.

See K&D Bond Direct's special event mailing for Mercedes-Benz on pages 57-59.

Pressley Jacobs Design was formed in 1985 by Wendy Pressley-Jacobs.

With over 18 years in the design consulting industry, Pressley-Jacobs has received recognition and awards from most major communications publications and organizations. She is an elected member of the prestigious "27 Chicago Designers," and currently sits on the executive committee of the Chicago chapter of the AIGA. In 1991, Women in Design/Chicago selected Pressley-Jacobs as "Woman of the Year."

Pressley Jacobs Design's clients consist primarily of major corporations and organizations such as Continental Bank, SC Johnson Wax, Whitman Corporation, and The Wyatt Company.

Pressley-Jacobs enjoys designing direct mail that's clever and thought-provoking; "We work from a standpoint of trying to understand clearly who a mailing's audience is, the messages and impressions intended for those audiences, and the best way to communicate those messages and impressions within the client's budget."

See Pressley Jacobs Design's direct mail postcard project for Typographers International Association on pages 73-75.

Jack Anderson has done it all. His background includes experience in virtually all areas of design: development of corporate and brand identity, collateral material, packaging, and environmental graphics. As one of the founders and guiding spirits of Hornall Anderson Design Works, his roster of clients is equally diverse, including international travel and hospitality companies, major retailers and distributors, and high technology companies. His firm also serves many medium and small clients with unique, challenging design needs.

Anderson frequently judges design competitions and shares his experiences with Art Directors Clubs across the country. He has been repeatedly recognized in the top annual design competitions and his firm has been featured in several publications including *HOW*, *Print*, and *Studio* magazines. In 1989, the Pantone Color Institute named Hornall Anderson Design Works the top graphic design firm of the year.

"We strive to do the best work in the business—to elevate every job above the ordinary," Anderson says. "Good design involves taking risks. When a client allows you to take a risk and it works, you've helped redefine and raise the standard."

See Hornall Anderson Design Works' Starbucks Coffee catalog campaign on pages 87-89.

Brian Miller *Graphic Designer*
Love Packaging Group
700 East 37th Street North
Wichita, Kansas 67219
Phone: (316) 838-0851
Fax: (316) 838-9120

Kevin Wade and Dana Lytle *Co-Principals*
Planet Design Company
229 State Street
Madison, Wisconsin 53703
Phone: (608) 256-0000
Fax: (608) 256-1975

John Sayles *Principal*
Sayles Graphic Design
308 Eighth Street
Des Moines, Iowa 50309
Phone: (515) 243-2922
Fax: (515) 243-0212

You might say Brian Miller "kicked off" what promises to be an illustrious career in direct mail and graphic design with a project featured in this book. "The vice president of our company asked me to design an important piece for his alma mater," explains the young designer. "I'd only been working for the company a couple months! This was the first project I did out of college." The Collegiate Alumni Reunion piece has put Miller in the spotlight by winning local advertising awards as well as being featured in several industry publications such as *Paperboard Packaging* magazine and *CASE Currents* magazine.

After graduating from Wichita State University in 1992, Miller began his professional career at Love Packaging Group, a packaging design, marketing, and manufacturing company. The firm specializes in designing packaging for clients including the Coleman Company, General Electric, and Twin Valley Popcorn.

"I enjoy designing direct mail because it gives me the chance to create something other than a box that ends up in a warehouse," the designer says. Miller likes to use corrugated in direct mail because of its industrial and utilitarian look.

See Love Packaging Group's nonprofit project for the Collegiate Alumni Reunion on pages 103-105.

Planet Design Company is directed by Kevin Wade and Dana Lytle, graphic designers who have gained invaluable experience working in advertising agencies and design firms across the country.

Kevin Wade, a native of Illinois, was trained in visual communication with an emphasis in illustration at Eastern Illinois University. Before settling in Madison, Wisconsin, he worked as both a freelance and staff designer in California and Illinois agencies.

Dana Lytle is a native of Montana. He earned his degree in graphic design from Montana State University while working for and running a graphic design studio.

Planet Design Company's major clients include Miller Brewing Company and Arlington International Racecourse. The studio's work has been featured in such publications as *Graphis Design, Graphis Poster, Communication Arts, HOW Self-Promotion, Print's Regional Design Annual, and International Logos and Trademarks,* among others. "We like to constantly explore new and interesting ways to intrigue people," says Lytle. "We take a team approach to direct mail design and involve the client, designers and copywriter from the beginning."

See Planet Design Company's direct mail fund-raising brochure for the American Players Theatre on pages 116-119.

Being headquartered in the middle of the United States—far from the acknowledged design centers of either coast—doesn't seem to have hurt John Sayles or his firm, Sayles Graphic Design. Sayles' client roster ranges from a New York-based publisher to several California universities, with plenty of Midwest companies rounding out the list.

Sayles worked for several local advertising agencies before starting Sayles Graphic Design with Sheree Clark in 1985. With Clark serving as Director of Client Services, three other staffers—a copywriter, a junior designer, and an assistant to Clark—round out the team.

The firm has won hundreds of awards, and Sayles' work has appeared in every major design publication. Sayles estimates about 30 percent of his organization's current workload is direct mail. "I love to design direct mail," admits the designer. "It's such an intimate medium. People usually read their mail when they're alone—even in a business setting. I know I've done a good job when they jump up and say 'Hey, come look at what I just got!'"

See a three-dimensional mailing Sayles Graphic Design developed for Berlin Packaging Company on pages 131-133.

Bibliography

Buckel, Harry J. "Economics, Efficiency Spur Shift To Ad Mail,"
Advertising Age, August 31, 1992.

Egol, Len. "Why Marvin Runyon Loves Direct Mail,"
DIRECT, February 1994.

Miller, Peter G. "Changing Consumers Spark Mail's Growth,"
Advertising Age, September 27, 1993.

About the Authors

Sheree Clark and Wendy Lyons have worked together on several projects over the years, but *Creative Direct Mail Design* is the first book they've co-authored.

Sheree Clark is a native of Saratoga Springs, New York. Since 1985, she has been a principal of Sayles Graphic Design in Des Moines, Iowa. She has written numerous articles for graphic arts trade publications and published her first book in 1984—a history project for Drake University. Clark holds a B.S. in Retail Marketing from Rochester Institute of Technology and a master's degree from the University of Vermont. Clark's passion for design extends to her free time activities: She collects art deco compacts and jewelry, Lucite handbags, and industrial design and packaging from the 1930s.

Growing up in the small town of Eldridge, Iowa, Wendy Lyons wrote her first poem at age 4. "Yes, it was about farm animals," she laughs. Lyons enjoys writing everything from poetry to direct mail copy to books and articles on graphic design. As copywriter for Sayles Graphic Design, she has an extensive background in writing direct mail campaigns for clients nationwide. Lyons holds a B.S. in Radio/Television from Kansas State University and is an accomplished television commercial and corporate video writer/producer. When she's not writing, Lyons enjoys heirloom flower gardening and collecting Victorian antiques.

Directory

Gladys Barton
245 Everit Avenue
Hewlett, New York 11557
(516) 295-4472

Bielenberg Design
John Bielenberg
333 Bryant Street
Suite 130
San Francisco, California 94107
(415) 495-3371

Bill Sosin Design
Bill Sosin
415 W. Superior Street
Chicago, Illinois 60610
(312) 337-4467

Blue Sky Design
Robert Little
6401 SW 132nd Court Circle
Miami, Florida 33183
(305) 388-1844

Cahan & Associates
Bill Cahan
818 Brannan Street
Suite 300
San Francisco, California 94103
(415) 621-0915

Cato Design
Ken Cato
254 Swan Street
Richmond, Victoria
Australia 3121
61 (3) 429-6577

Clifford Selbert Design
Laura Duffy
2067 Massachusetts Avenue
Cambridge, Massachusetts 02140
(617) 497-6605

Concrete
Jilly Simons
633 South Plymouth Court
Suite 208
Chicago, Illinois 60605
(312) 427-3733

Concrete Design
Communications, Inc.
John Pylypczak
2 Silver Avenue
Toronto, Canada M6R 3A2
(416) 534-9960

COY, Los Angeles
John Coy
9520 Jefferson Blvd.
Culver City, California 90232
(310) 837-0173

Cronan Design
Michael Cronan
11 Zoe
San Francisco, California 94107
(415) 543-3387

David Carter Design Associates
David Carter
4112 Swiss Avenue
Dallas, Texas 75204
(214) 826-4631

Design Ahead
Kristin La Favor
118 East 26th Street
Suite 301
Minneapolis, Minnesota 55404
(612) 879-0412

Designers
Martha Carothers
103 Recitation Hall
University of Delaware
Newark, Delaware 19716
(302) 831-2244

Design Goddess International
Deb Jansen
3503 N. Lakewood, #3
Chicago, Illinois 60657
(315) 248-1375

Elton Ward Design
Steve Coleman
4 Grand Avenue, Parramatta
NSW 2124, Australia

eyeOTA
David Kilvert
6120 Bristol Parkway
Culver City, California 90230
(310) 417-8110 ext. 826

Philip Fass
1304 State Street
Cedar Falls, Iowa 50613
(319) 277-6120

Geffen Records
Kevin Reagan
9130 Sunset Blvd.
Los Angeles, California 90069
(310) 285-2780

Gottschalk + Ash International
Fritz Gottschalk
Böcklinstrasse 26
Post Fach 268
Zürich, Switzerland 8032
01 382-1850

Jean Govoni
25 Oak Lane
Sag Harbor, New York 11963
(516) 725-4109

Grafik Communications Ltd.
Melanie Bass
1199 North Fairfax Street
Suite 700
Alexandria, Virginia 22314
(703) 683-4686

Hal Riney & Partners
Andrew Gray
224 S. Michigan Avenue
Chicago, Illinois 60604
(312) 697-5700

Henry Russell Bruce
Steve Erickson
1957 Blairs Ferry Road NE
Cedar Rapids, Iowa 52402
(319) 393-2656

HerRainco Design Associates Inc.
Ray Hrynkow
301-40 Powell Street
Vancouver, British Columbia
Canada V6A 1E7
(604) 688-5334

Hornall Anderson Design Works
Jack Anderson
1008 Western
Suite 600
Seattle, Washington 98104
(206) 467-5800

International Events
Mark Drury
640 Homer Avenue
Palo Alto, California 94117
(415) 324-0852

IQ&J Group 121
Robert Davis
855 Boylston Street
Boston, Massachusetts 02116
(617) 954-1000

Jager DiPaola Kemp Design
Michael Jager
308 Pine Street
Burlington, Vermont 05401
(802) 864-5884

John Brady Design Consultants
John Brady
Three Gateway Center
17th Floor
Pittsburg, Pennsylvania 15222
(412) 288-9300

Joss Design Group
Marty Regan
1 East Erie Street
Suite 310
Chicago, Illinois 60611
(312) 944-0644

K&D Bond Direct
Bruce Bennett
8 Kippax Street
Surry Hills, Australia 2010
(02) 288-9000

Kiyoshi Kanai, Inc.
Kiyoshi Kanai
115 East 30th Street
New York, New York 10016
(212) 679-5542

The Levy Organization
Marcy Lansing Young
980 N. Michigan Avenue
Suite 400
Chicago, Illinois 60611
(312) 335-5016

Lipman Hearne
Hal Kugeler
303 East Wacker Drive
Suite 1030
Chicago, Illinois 60601
(312) 946-1900

Liska & Associates, Inc.
Steven Liska
676 North St. Clair, #1550
Chicago, Illinois 60611-2902
(312) 943-4600

Louey/Rubino Design Group
Robert Louey
2525 Main Street
Suite 204
Santa Monica, California 90405
(310) 396-7724

Love Packaging Group
Brian Miller
700 East 37th Street North
Wichita, Kansas 67219
(316) 832-3293

Lynne Hoinash & Associates
Molly Eklund-Hund
313 Rodney Court
Princeton, New Jersey 08540
(609) 683-9316

Marc English: Design
Marc English
37 Wellington Avenue
Lexington, Massachusetts 02173
(617) 860-0500

Mauk Design
Mitchell Mauk
636 Fourth Street
San Francisco, California 94117
(415) 243-9277

McMonigle & Spooner
Stan Spooner
818 East Foothill Blvd.
Monrovia, California 91016
(818) 303-1090

Milton Bradley
Jim Bremer
443 Shaker Road
East Longmeadow, Massachusetts
01028
(413) 525-6411

Mireille Smits Design
Mireille Smits
8554 Moore Road
Indianapolis, Indiana 46278
(317) 299-4653

Moore Moscowitz
Tim Moore
99 Chauncy Street
Suite 720
Boston, Massachusetts 02111
(617) 482-8180

Nesnadny + Schwartz
Mark Schwartz
10803 Magnolia Drive
Cleveland, Ohio 44016
(216) 791-7721

Norwest Financial Inc.
Barry Norgaard
206 Eighth Street
Des Moines, Iowa 50309
(515) 248-7493

Olson Johnson Design Company
Haley Johnson
3107 East 42nd Street
Minneapolis, Minnesota 55406
(612) 722-8050

Paprika
Louis Gagnon
3620 Laval Avenue
Montreal, Quebec
Canada H2X 3C9
(514) 845-6978

Peat Jariya Design
Peat Jariya
13164 Memorial Drive, #222
Houston, Texas 77079
(713) 523-5175

Peterson & Company
Bryan Peterson
2200 North Lamar
Suite 310
Dallas, Texas 75202
(214) 954-0522

Pittard Sullivan Fitzgerald
Billy Pittard
6430 Sunset, #200
Hollywood, California 90028
(213) 462-1190

Planet Design Company
Dana Lytle
229 State Street
Madison, Wisconsin 53703
(608) 256-0000

Polese Clancy Inc.
Ellen Clancy
10 Commercial Wharf West, #511
Boston, Massachusetts 02110
(617) 367-6730

The Post Press
Martha Carothers
16 Thompson Lane
Newark, Delaware 19711

PPA Design
Byron Jacobs
D3
11 Macdonnell Road
Hong Kong
(852) 810-6640

Pressley Jacobs Design
Wendy Pressley-Jacobs
101 North Wacker, Suite 100
Chicago, Illinois 60606
(312) 263-7485

PRINCIPAL COMMUNICATIONS
PETER LARD
777 THIRD AVENUE
23RD FLOOR
NEW YORK, NEW YORK 10017
(212) 546-2066

PUCCINELLI DESIGN
KEITH PUCCINELLI
116 E. DE LA GUERRA STREET
NUMBER 2
SANTA BARBARA, CALIFORNIA 93101
(805) 965-5654

RIGSBY DESIGN, INC.
LANA RIGSBY
5650 KIRBY DRIVE
SUITE 260
HOUSTON, TEXAS 77005
(713) 660-6057

ROBIN COTTLE DESIGN
ROBIN COTTLE
518 SUNSET AVENUE
VENICE, CALIFORNIA 90291
(310) 392-4909

SACKETT DESIGN ASSOCIATES
MARK SACKETT
864 FOLSOM STREET
SAN FRANCISCO, CALIFORNIA 94107
(415) 543-1590

SAM SMIDT STUDIO
SAM SMIDT
666 HIGH STREET
PALO ALTO, CALIFORNIA 94301
(415) 327-0707

SAYLES GRAPHIC DESIGN
JOHN SAYLES
308 EIGHTH STREET
DES MOINES, IOWA 50309
(515) 243-2922

SEGURA INC.
CARLOS SEGURA
361 WEST CHESTNUT STREET
FIRST FLOOR
CHICAGO, ILLINOIS 60610
(312) 649-5688

SIBLEY/PETEET DESIGN INC.
REX PETEET
965 SLOCUM
DALLAS, TEXAS 75207
(214) 761-9400

STEVE MEEK INC.
STEVE MEEK
743 W. BUENA
CHICAGO, ILLINOIS 60613
(312) 477-8055

STEWART MONDERER DESIGN INC.
STEWART MONDERER
10 THACHER STREET
SUITE 112
BOSTON, MASSACHUSETTS 02113
(617) 720-5555

STOLTZE DESIGN
CLIFFORD STOLTZE
49 MELCHER STREET, FOURTH FLOOR
BOSTON, MASSACHUSETTS 02210
(617) 350-7109

THE STUDIO GROUP
JOHN HINES
1426 PEARL STREET, #211
BOULDER, COLORADO 80234
(303) 440-1680

SUPON DESIGN GROUP
SUPON PHORNIRUNLIT
1700 K STREET N.W.
SUITE 400
WASHINGTON, D.C. 20006
(202) 822-6540

TAKEO COMPANY LTD.
HIRAKU KIDO
3-12, KANDA NISHIKI-CHO
CHIYODA-KU
TOKYO, JAPAN 101

TARGETCOM INC.
RICARDO QUAYAT
401 EAST ILLINOIS
SUITE 333
CHICAGO, ILLINOIS 60611
(312) 822-1100

THIRST
RICK VALICENTI
855 WEST BLACKHAWK STREET
CHICAGO, ILLINOIS 60622
(312) 951-5251

TOM FOWLER INC.
THOMAS FOWLER
9 WEBBS HILL ROAD
STAMFORD, CONNECTICUT 06903
(203) 329-1105

TOWERS PERRIN
JIM KOHLER
200 WEST MADISON
SUITE 3300
CHICAGO, ILLINOIS 60606-3414
(312) 609-9842

VAUGHN WEDEEN CREATIVE
RICK VAUGHN
407 RIO GRANDE NW
ALBUQUERQUE, NEW MEXICO 87104
(505) 243-4000

VISUAL EYES
E.J. DIXON III
1044 PASSIFLORA AVENUE
ENCINITAS, CALIFORNIA 92024
(619) 942-3940

WAGES DESIGN
BOB WAGES
1201 WEST PEACHTREE STREET
SUITE 3630
ATLANTA, GEORGIA 30327
(404) 876-0874

WILLIAM REUTER DESIGN
WILLIAM REUTER
657 BRYANT STREET
SAN FRANCISCO, CALIFORNIA 94107
(415) 764-1699

WOOD DESIGN
TOM WOOD
133 WEST 19TH STREET
NEW YORK, NEW YORK 10011
(212) 924-0770

WORKSIGHT
SCOTT SANTARO
46 GREAT JONES STREET
NEW YORK, NEW YORK 10012
(212) 777-3558

YASHI OKITA DESIGN
YASHI OKITA
2325 THIRD STREET
SUITE 220
SAN FRANCISCO, CALIFORNIA 94107
(415) 255-6100